BASIC

AIRBRUSH

PAINTING TECHNIQUES

A PRACTICAL GUIDE TO CREATIVE AIRBRUSHING

JUDY MARTIN

**NORTH
LIGHT
BOOKS**

CINCINNATI, OHIO

First published in 1994 by
HarperCollins Publishers
London

First published in the United States by
North Light Books, F&W Publications, Inc.,
1507 Dana Avenue, Cincinnati,
Ohio 45207 (1-800-289-0963)

© Nigel Osborne, 1994

Designed and produced by Nigel Osborne

ISBN 0-89134-585-X

Produced by HarperCollins Hong Kong

CONTENTS

INTRODUCTION

The airbrush was invented by a watercolourist, Charles Burdick,
in 1893, as a tool for laying colour washes. It was
not well received by his fellow painters, who disapproved
of the idea of a mechanical painting tool, but its potential was
quickly discovered by artists practising in other fields.
The airbrush became a valuable tool for commercial art forms,
photo-retouching and decorative crafts such as
ceramic and fabric painting. It became specially associated with
graphic art and illustration, and has been represented
mainly in that context in recent technical manuals
and inspirational books on airbrushing. The common understanding
about airbrushing is that the techniques necessarily produce
a particular kind of flawless, heavily modelled and
glossily finished imagery.

The primary purpose of this book is to reinstate the airbrush
as a painter's tool and explore the potential of
airbrushing for many different types of image-making. The airbrush
does produce characteristic marks and colour
effects, but these are no more attached to certain styles of

painting or illustration than are the kinds of marks made by
a sable or hog-bristle paintbrush. It is up to you to
use the airbrush in a way that suits the style and subject matter
of your own work.

The demonstrations, artwork samples and detailed projects
in this book are designed to teach you basic techniques
and methods at the same time as suggesting
a range of possible applications and effects. You can use
them as a starting point or initial inspiration, then go on to discover
your own creative potential as an airbrush artist.

Because the airbrush is a delicate mechanical instrument,
there are right and wrong ways to treat it, but no right or wrong
ways to paint with it once you have mastered basic
techniques and the routine maintenance procedures for
keeping your equipment in good condition. The materials you can
use in airbrushing and various methods of applying them
are explained here in simple, practical terms, and the visual
possibilities are fully illustrated. But as with any painting method, the
right approach need only be defined as the one that works
for you; so feel free to experiment and learn to enjoy
the versatility of airbrushing techniques.

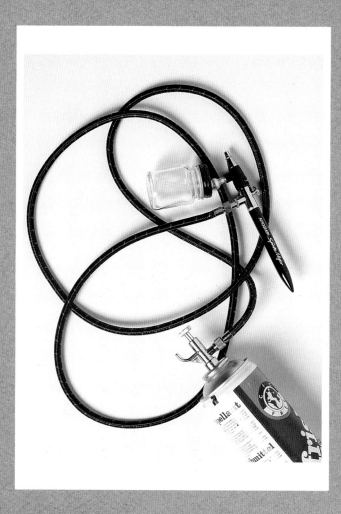

Choosing an Airbrush

Practical information on how the
airbrush works and the essential items
of equipment that you need to get
started as an airbrush artist

HOW THE AIRBRUSH WORKS

ALL AIRBRUSHES WORK ON THE SAME BASIC PRINCIPLES
AND HAVE SIMILAR COMPONENTS, BUT THERE ARE VARIATIONS
IN DESIGN AND YOU NEED TO FIND THE MODEL THAT
IS RIGHT FOR YOU

An airbrush is a large investment, but it should give years of useful work, so it is important to understand the basic principles of how it functions and to choose the right model for what you want to do.

The airbrush is a unique painting tool in that it does not touch the working surface. You need to feel comfortable about manipulating its physical shape and weight. When you go to buy an airbrush, explain carefully to the supplier what kind of work you intend to do with it, and get advice on a suitable model. Because airbrushing equipment is specialized, retailers are generally knowledgeable and enthusiastic, and should be prepared to let you take your time. Hold the airbrush in your hand and try to imagine controlling its movement without relying on the direct contact between painting tool and paper.

Cone of spray Colour medium and air meet in the nozzle of the airbrush and are tightly compressed, but open out into a broad cone of fine, even colour spray.

ATOMIZER

The technical variations between different airbrush models relate to control of the air and paint supplies and therefore of the spray pattern. But all work on the same basic principle – a channel of compressed air meets a channel of liquid medium within a confined space, and the combination produces a fine spray of colour particles.

The air is fed into the body of the airbrush via a hose attached to the air source. The paint is channelled along a needle through the centre of the airbrush; the liquid colour is fed on to the needle from a cup or jar at the front of the tool.

Colour feed The DeVilbiss Aerograph Super 63 airbrush is an example of a gravity-feed model with integral colour cup mounted on top of the airbrush body.

The tip of the needle passes into the airbrush nozzle, where it meets the pressurized air and atomizes. The nozzle opening is very fine, so the spray is highly compressed as it leaves the airbrush but gradually opens out into a cone shape. The further it gets from the airbrush before meeting a surface, the wider the area of spray. This principle is familiar from ordinary domestic types of sprayers, like a plant mister or spray-can of furniture polish.

What comes out of the airbrush is a mass of fine colour particles, but once they land evenly on a surface, they appear to form smooth, flat colour areas. The finest spray comes from the paint and air meeting within the airbrush and passing out through the tiny aperture in the nozzle. This is called internal mixing. The principle of atomization also works when the paint and air supplies are brought together just outside the airbrush tip – external mixing – but the spray is coarser and less controllable.

Only a few airbrush types have external mixing and they are mostly intended for colouring up 3-D models and backgrounds quite broadly. For painting and graphic artwork, you need the better-quality spray from an internal-mix airbrush.

COLOUR FEED

The paint medium for airbrushing has to be of a smooth liquid consistency, with no lumps or gritty particles that could clog the airbrush nozzle or build up on the needle. It is easiest to use purpose-made liquid watercolours or water-based inks, but you can use any medium provided it is suitably diluted to flow freely.

The airbrush is fitted with a colour cup or jar that holds a quantity of liquid medium and channels it consistently on to the needle while the airbrush is in action. The paint container may be within the body of the airbrush or closely attached. Some form an integral part of the airbrush, others slot in and are interchangeable so you can use different sizes and weights, depending on the type of medium you are spraying and how much of it you need.

The paint supply passes into the airbrush by one of two methods – gravity feed or suction feed. A gravity feed colour cup is positioned on top of the airbrush and the liquid naturally flows downward from it. A suction feed cup may be mounted on the side of the airbrush or underneath. The force of the pressurized air passing through the airbrush sucks the colour in.

The choice between gravity or suction feed makes a difference to the handling of the airbrush. The size, weight and position of the colour cup affects the balance of the tool in your hand. For example, a glass paint jar attached to the side or underside creates a slight drag on the airbrush and has to be kept clear of the surface you are spraying on. A top-mounted, inset or side-mounted lightweight cup disturbs the balance very little and hardly gets in the way.

AIR AND PAINT CONTROL

The other main variation between airbrush models is the mechanism for controlling the mix of air and paint. In the simplest types of air-

brushes, you have a lever or button that moves in one direction only, releasing both air and paint immediately in a fixed ratio – this is called single-action.

In a double-action tool, the air supply can be started before the paint supply is introduced. Fixed double action airbrushes are operated by a lever that you press down with your forefinger. As you start to press, the air is released; as you press down further, the paint supply comes in. This also gives you a fixed air/paint ratio.

For the greatest range of control in airbrush painting, you need an independent double-action airbrush, the most versatile type. This has a push-button control that operates in two directions – downward pressure releases air; pulling back on the button releases paint. You can thus vary the air/paint ratio continuously while spraying, according to the pressure you exert in either direction.

This is a sophisticated mechanism that takes some getting used to, and it will be a while before you feel fully in control. However, you can quickly get enough control to produce satisfactory initial results in your artwork, and it is by creating the work that you will learn what you and your airbrush can do.

AIRBRUSH MODELS AND ACCESSORIES

Double-action airbrushes are precision instruments and highly engineered. In the majority, the main airbrush body is made of metal; there are all-metal models and others with a metal front section fitted to a plastic handle which houses the paint needle and its mechanism.

Airbrushes with non-metal casings are naturally more lightweight than metal types. This kind of design was at one time applied mainly to inexpensive single-action airbrushes but has now been adapted to more sophisticated double-action models. Some people prefer the weight and stability of a metal airbrush, while others prefer the easy manipulation of the lighter-weight models.

For certain models, you can obtain different types of screw-in nozzles, which provide you with special effects such as spattering, broad spray or fine line. With

Airbrush models These pictures show a representative range of airbrush models which demonstrate typical body shapes and colour feed accessories.

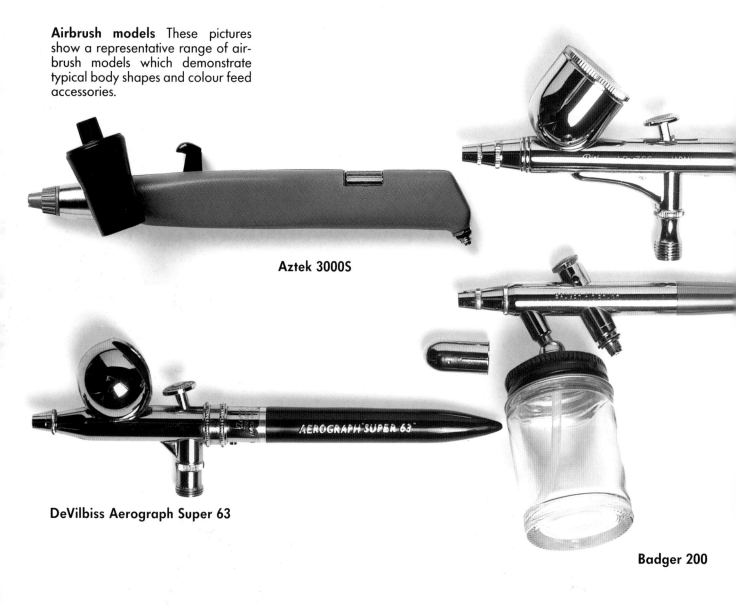

Aztek 3000S

DeVilbiss Aerograph Super 63

Badger 200

double-action types that have a general-purpose nozzle, the way you manipulate the airbrush and its control enables you to vary the spray pattern and surface effects.

CLEANING
AND MAINTENANCE

Because the airbrush is a delicate instrument, there are limits to what you can and should do to repair it yourself if it goes wrong. The instructions for use supplied with it by the manufacturer will include advice on maintenance and trouble-shooting, and there is a summary chart of common problems on pages 124-125 of this book.

The most important thing is to keep your airbrush clean. Flush it out thoroughly with clean water when you have finished painting, to eliminate all the colour. After the water sprays clear, let air pass through the airbrush to dry out the interior and nozzle.

You can spray out on to paper towels or into a plastic container. For some airbrush models, there is a purpose-made container you can buy with a nozzle-housing leading to an enclosed reservoir. This prevents large amounts of paint and water droplets from being released into the surrounding air.

CHOOSING AN AIRBRUSH

- Ask to see independent double-action models.
- Weigh the airbrush in your hand. Move it around as if spraying on to paper.
- Consider the position and size of the colour cup(s) that go with that model. Does the airbrush still feel comfortable and balanced with the colour cup attached?

Rich AB300

DeVilbiss Aerograph Sprite

AIR SOURCES

A RELIABLE SOURCE OF CLEAN, MOISTURE-FREE AIR IS
ESSENTIAL FOR DETAILED AIRBRUSH PAINTING.
THERE ARE TWO BASIC OPTIONS, BOTH PURPOSE-MADE FOR
AIRBRUSH WORK – A CAN OF COMPRESSED AIR,
OR A MOTORIZED COMPRESSOR

AIR CANS

The air can is attached to the airbrush via a control valve and hose. When the valve is opened, operation of the airbrush releases the flow of pressurized air. The main advantage of this source is that individual cans are relatively inexpensive, so they may be useful to the beginner trying out airbrushing equipment before deciding on further investment.

The major disadvantage is that the can contains a limited amount of air. Pressure within the can drops as the supply is used, sometimes disrupting the spray pattern from the airbrush. Eventually, the can runs out completely, and this may happen without warning while you are in the middle of spraying.

The air can is essentially a short-term solution. Cans are used up very quickly, even when you are simply practising airbrush control, so the cost of your air source escalates. As soon as you feel comfortable with the tool and more ambitious in your airbrushing projects, you should invest in a small compressor which provides a permanent source of pressurized air.

COMPRESSORS

A compressor is an electrically-powered, motorized machine designed to provide a continuous source of pressurized air for airbrushing. Compressors vary greatly in size, operation and capacity, from very small mini-compressors to large-scale models for professional studio use that allow connection of up to four airbrushes at a time.

For the individual airbrush artist, there are two main types of interest. The ideal compressor for painting and graphic work is one that has a storage tank in which the air supply remains at constant pressure. When the compressor is switched on, the motor starts and fills the tank with pressurized air; a regulator allows you to set the required pressure for the type of airbrush and medium you are using. As the air supply is fed into the airbrush, the compressor automatically kicks in to replenish the tank to the pre-set pressure as required. A moisture trap is fitted to take out dampness from the air

Diaphragm compressor This type of compressor is easy to use and relatively inexpensive. The air supply is constant, but not completely even.

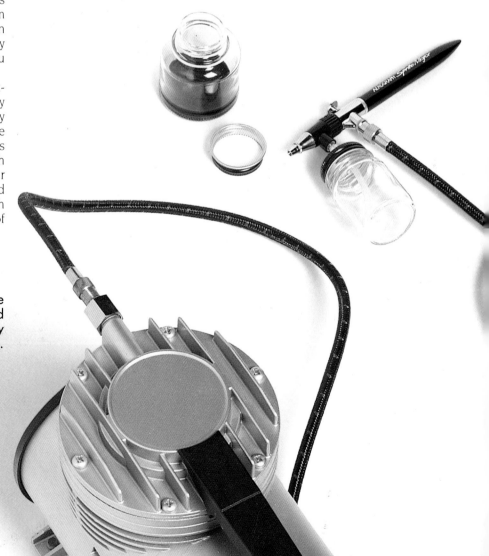

Small storage compressor
Compact, quiet and reliable, the small storage compressor provides a constant, even flow of air and is ideal for regular studio use.

supply that could affect the consistency of the paint medium while you are spraying.

Modern small storage compressors for single airbrush outlets are compact, portable, quiet and safe to use. The motor makes a low noise while filling the tank initially and when restoring air pressure during spraying; otherwise the compressor is silent.

The less expensive and slightly less reliable option is a diaphragm-type compressor which pumps the

Air can A useful source for initial airbrushing practice or occasional use, the air can has the disadvantages for continuous working of gradual pressure drop and limited supply.

Multi-outlet compressor Some storage compressors provide two to four air outlets, enabling two or more airbrush artists to work at the same time without interruption to the air supply.

air directly through to the airbrush, without tank storage. The disadvantage of the direct compressor is that the air supply typically comes through in a pulsing motion, making the airbrush spray less consistent. It is possible to fit a pulse eliminator, attached between the compressor and the airbrush hose, and also a moisture trap and pressure regulator as accessories. You do need all these features if you are using the compressor for detailed artwork, so you may find that in terms of cost and convenience, you are better off choosing a tank compressor.

Some compressors are designed to work on relatively low maximum air pressure, which is measured in units called psi (pounds per square inch) or bar. In others, there is a higher maximum capacity, but you can regulate it to obtain the correct pressure for your airbrush and medium. Ask the retailer's advice on this point if you are not sure.

AIR HOSES AND CONNECTORS

If all of your airbrushing equipment comes from one manufacturer, the air hose and connectors that attach it to the airbrush at one end and the compressor at the other will be designed to fit together.

Air hoses are of three main types: fine, straight plastic hose; coiled plastic hose; and rubber hose covered with braided cloth. You may not have a choice, but if you do, take account of the weight of the hose as a factor in your airbrush control. The braided rubber hose is very durable, but heavier than the plastic types, sometimes causing a slight drag on the airbrush body.

If you consider buying an airbrush and compressor made by different manufacturers, check that you can obtain connectors that enable you to fit one to the other via a suitable hose. As this commonly occurs, there are specially made adaptors.

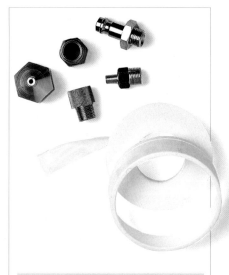

CONNECTORS

This picture shows a range of standard adaptors for coupling air hoses and compressors. The quick-release connector (top) is useful if an airbrush is being used that is compatible with only one type of hose. Thread-seal tape (bottom right) helps to ensure tight, leak-proof connectors.

General studio equipment
Items that you will find useful or essential includes pencils and erasers, a plastic and a steel ruler, French curves, sable or synthetic hair paint-brushes, masking tape, a sharp craft knife with inter-changeable blades for trim-ming paper, and a fine surgical scalpel for delicate mask-cutting.

STARTING WORK

Apart from the airbrush and air source, the only essential items you need to begin work are colours and paper.

There are other materials related to particular techniques, such as masking fluid and mask-ing film, that you will need to obtain if you want to achieve the given effects in your airbrushed pictures. These are introduced in relation to specific exercises and projects throughout the book.

Try to work in a large, well-ventilated room and allow plenty of space to lay out your materials. Airbrushing is not a messy tech-nique, but you do need easy access to your colours and mask-ing materials, and space for test-ing spray quality and flushing out the airbrush. Keep a spare sheet of paper by your worktop, on which you can test colours and spray textures before applying them to finished artwork.

● Liquid colours – bottled watercolours or acrylic inks, with droppers for loading – are easiest to handle and ideal for painting, graphic work and photographic handtinting. You can alternatively use tube watercolours or gouache, watered down to liquid consistency and transferred to the airbrush colour cup using a paintbrush.

● Inexpensive cartridge paper is adequate for airbrushing practice. For finished work, choose from heavy cartridge, watercolour paper, lightweight illustration board or purpose-made, ultra-smooth airbrushing papers.

● A non-specialist item that comes in very handy is a light-weight plastic measuring jug or an emptied washing-up liquid bottle. When you are flushing out the airbrush between colour changes or after you finish paint-ing, it is helpful to have a gener-ous supply of clean water to hand.

● A good supply of kitchen paper towels is invaluable for absorbing flushed-out spray or mopping up spills.

● Good ventilation is important; the airbrush releases clouds of fine colour particles into the air, not all of which fall on to or adhere to the working surface. It is also advisable to wear a simple face mask of the kind sold in DIY stores to protect against sanding and spraying.

● You can work on an upright, tilted or horizontal surface. This is largely a matter of personal pref-erence and it is up to you whether you use an easel, adjustable drawing board or flat tabletop. It may also depend on the type of airbrush you are using and the requirements of a particular piece of work: for example, you cannot get very close to a horizontal surface if your airbrush has a suction-feed colour jar mounted underneath the airbrush.

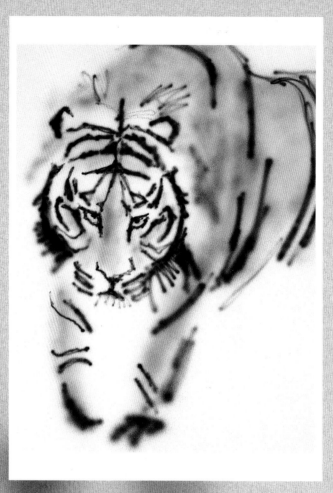

2

GETTING TO KNOW YOUR AIRBRUSH

With just a little practice to help you
get the feel of the airbrush,
you can soon start using basic
techniques to produce interesting and
attractive images

BASIC TECHNIQUE

YOUR FIRST TASK IS TO LEARN HOW THE AIRBRUSH CONTROL
BUTTON WORKS AND CO-ORDINATE THAT ACTION WITH THE
MOVEMENTS YOU MAKE WHILE DRAWING LINES OR SHAPES

There are two basic factors governing the effect of your spraying with a double-action airbrush. One is the ratio of paint to air, which you regulate with the movement of the control button – press down for air, pull back for paint. The other is the distance of the tool from the paper. Close to the paper, you have only a narrow cone of spray from the nozzle, which makes a dot if you hold the airbrush still, or a line if you let it move. If you bring the airbrush up from the paper, the cone of spray is wider and spreads further. The paint particles are also less concentrated, so the colour is lighter.

You will see a 'drift' of colour particles beyond the immediate area of spraying. This gives the characteristic soft effect of airbrushing and you will get used to the lack of 'edge'.

It is easiest to use liquid watercolours or acrylic inks, which come in bottles with droppers fitted in the lids, so you can quickly load the airbrush colour cup. But you can alternatively work with well-diluted tube watercolour or gouache paints – mix well to brush out any lumps of colour that might clog the airbrush nozzle. Use a large, soft paintbrush to load the wet paint into the colour cup.

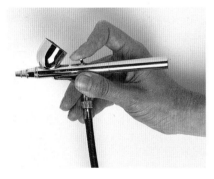

1 Hold the airbrush like a pen and start the air supply by pressing the control button straight down with your forefinger.

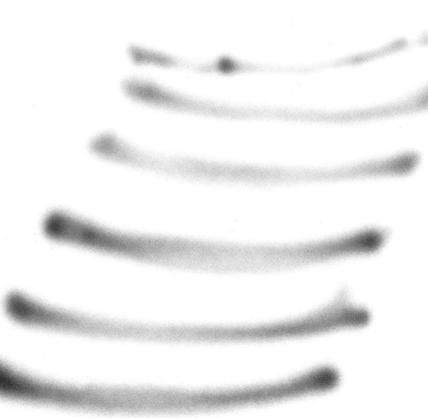

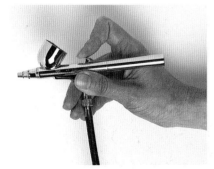

2 Pull back gently to bring in the paint supply. Practise until you can combine both actions in one smooth motion. To stop the spray, simply reverse the process.

STARTING AND STOPPING
You may notice a concentration of colour at the beginning and end of your strokes, or where you have hesitated in drawing a line. You will gradually learn to move in and out of the passes more evenly.

DRAWING A CLEAN LINE

If you keep close to the surface and spray strongly, you obtain a heavy line, but if you are too close the colour will blow into spidery trails.

SPRAYING HEIGHT

As you move further from the paper, the spray width gradually increases. These examples show dots and lines drawn with the airbrush at 8mm (¼in), 2cm (¾in), 4cm (1½in) and 6cm (2½in) from the paper.

FREEHAND SPRAYING

IN YOUR INITIAL FREEHAND SPRAYING EXERCISES, JUST LET
YOURSELF GET THE FEEL OF THE AIRBRUSH AND WHAT IT
CAN DO, USING LINES AND LOOSE PATCHES OF COLOUR

While getting to know your airbrush, just work as if you were doodling with a pen on paper, creating abstract patterns, simple shapes, or letters and words. All you are doing at this stage is learning to control the dual action of the air and paint supplies, and finding out the intensity of the spray patterns at different distances.

Once you start to spray, it becomes quite addictive and you can use up acres of paper without producing any very significant results. Equip yourself with a cheap pad of plain paper, minimum A4 size, or lots of larger sheets of inexpensive layout or cartridge paper.

You need to feel free to experiment without worrying about wasting expensive art materials, but use a paper size that is large enough to let you move the airbrush freely and develop fluid, even strokes.

DIRECTIONAL LINES
Draw regular, evenly spaced lines; you may find it more difficult than you expect to get a smooth flow. Use criss-cross lines to create a grid and fill it in with linear patterns and varying tones.

FLOWING CURVES
When practising looped strokes like this, keep your hand moving easily to eliminate irregular thickening of the lines. Make sure the first colour is dry, then shade another one into the pattern.

AIRBRUSH WRITING

An alphabet seems like an easy exercise, but it takes concentration to control the scale and precision of the letterforms in relation to one another. Try signing your name with the airbrush to see how much it resembles your written signature.

Practical tip

You do not need to flush out the airbrush completely every time you change colours. When you use up the first colour, load in the new and spray on to paper kitchen towel for a few seconds until the new colour comes through cleanly.

The exceptions are pale colours, especially following a darker colour that stains readily – such as yellow after blue or red. Then you should rinse the airbrush out with clean water before reloading.

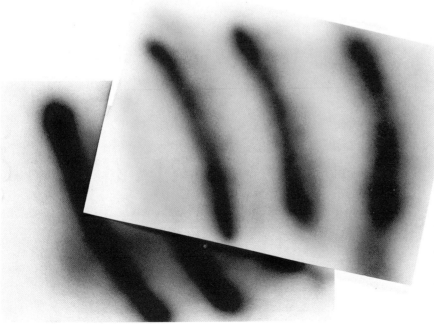

OVERLAID COLOURS

Spray an area of flat colour, then spray bands of another colour on it and let them blend roughly at the edges of the overlaid strokes. Notice the slight flare at each end of the purple bands; an extra build-up of colour is not unusual where you start and stop the stroke.

GRADED TONES AND COLOURS

THE AIRBRUSH ENABLES YOU TO CREATE SMOOTH VARIATIONS
IN THE INTENSITY OF A COLOUR OR SHADE ONE
COLOUR INTO ANOTHER, BUILDING UP GRADUALLY TO
THE FINISHED EFFECT

One of the most attractive features of airbrush painting is the way the spray creates flawless transitions between different colours and tones. This is because of the fineness of the flow of medium and the lack of surface contact, and it is characteristically different from painting with an ordinary brush. For example, when you lay in a watercolour wash with a paintbrush, you sometimes get bands and ridges of colour, where the concentration of pigment varies, or the brush itself has created a distinct edge to the stroke. Once it has dried, you cannot blend in a new colour without 'seeing the join'.

Because the airbrush sprays tiny colour particles, the colours blend more finely. There is no natural hard edge to the colour area, so that even when the paint dries immediately, another colour sprayed into or over the first merges subtly. As the tool does not touch the paper surface, you cannot get accidental streaks.

To obtain effects of graded tone, you can simply vary the amount of spray in different areas, or you can blend two similar colours that have different tonal values. To produce colour variations, you can spray different colours side by side, or overlay one on another.

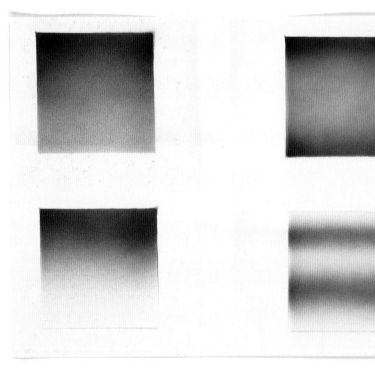

Practical tip
If you spray graded tones free-hand to form a regular shape such as a rectangle, you will see that the edges are uneven because of the overspray and the colour may also be unevenly distributed on the borders of the shape. You can eliminate these effects when you come to apply masking techniques (see page 32), by spraying right over the edges of the mask.

GRADED TONES
Tonal gradations are achieved in two ways: by moving the airbrush closer to or further from the surface, and by respraying to build up the density of colour. This can form a simple transition from one tone to another, or alternating bands, depending on your spray pattern.

1 To blend two colours, spray the required area of the first colour, allowing it to fade off at one side by pulling up gradually and releasing the control button.

2 Work the second colour in the same way, angling the air-brush to make the colour drift towards the previously sprayed area.

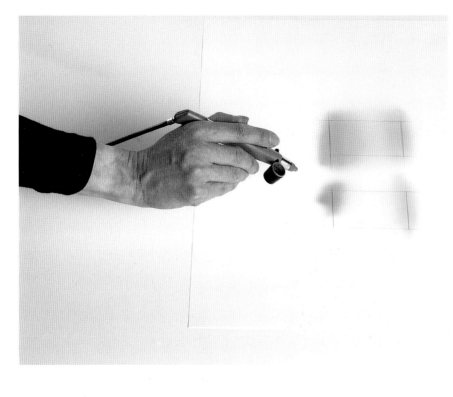

3 Different effects are obtained depending on whether you are blending similar colours that merge together or contrasting hues.

GRADED COLOURS

These colour variations work in the same way as the tonal examples, moving from light to dark or in alternate banding. The combination of colours produces intermediary hues as well as modifying the tonal scale.

PROJECT: ANIMAL SKETCHES

CHOOSE A SUBJECT WITH SOME GRAPHIC INTEREST THAT
YOU CAN FOCUS ON IN YOUR DRAWING, LIKE THE
TIGER'S PATTERN OF STRIPES

When you have completed enough basic exercises to feel you have begun to get control of your airbrush, you will naturally want to move on quickly to producing an image. Freehand line drawings of animals and birds are a useful step forward from the abstract doodles. Here you learn more about confining the spray to create different line qualities, and applying the technique descriptively.

The difficult part in line work is controlling the passage of the airbrush nozzle when it does not touch down on the paper. With a pencil or crayon, for example, the pressure of the tool on the surface helps you to create a firm line. It is easier initially if you work on a fairly large scale. Tape a big sheet of paper to a drawing board or to the wall, and let your hand move freely as you follow the lines of your subject, to give the sketch an expressive feeling.

If you are unconfident to start with, make a quick pencil or charcoal sketch and use it as a basis for the airbrushing. When you have produced a satisfactory result that way, go on to a completely freehand airbrush drawing.

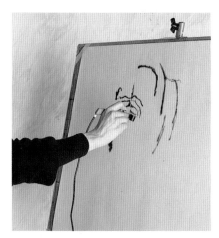

1 Load the airbrush with black watercolour. Start with a main outline or pattern area that helps you to set the scale of your drawing and its position on the paper. Keep the airbrush close to the surface – you can rework the lines if they are too fine to begin with.

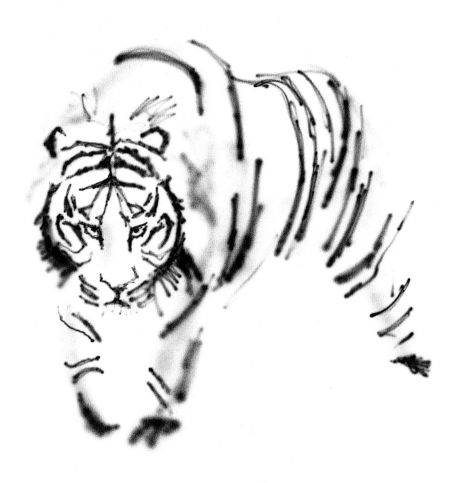

EQUIPMENT
- Airbrush and air source
- Large sheets of paper
- Masking tape
- Black and brown watercolours

2 Build up the line work gradually and develop solid blacks by hatching lines together. When you have the full shape and pattern sketched out, pull back a little and spray some lightweight 'shading' to model the form. From the greater distance, the black watercolour shades to grey.

3 Reload the airbrush with light brown and spray gently from a short distance away to lay in soft patches of colour. Angle the airbrush carefully, so that in some areas you preserve the white of the paper.

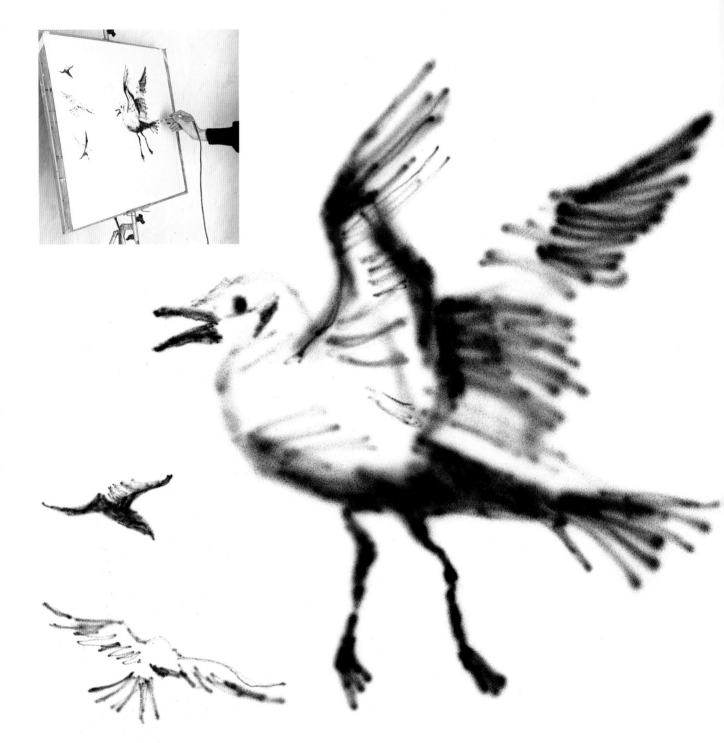

DRAWING BIRDS
Birds make an interesting subject for airbrushing practice, because the free, open shapes they make in flight lend themselves to the loose qualities of airbrushed lines and tones. You can vary the scale of your drawings as you acquire greater control of the line work.

LINE AND WASH

THE CLASSIC TECHNIQUE OF COMBINING INK LINE WITH
WATERCOLOUR WASHES TAKES ON AN ATTRACTIVELY
DIFFERENT CHARACTER WHEN THE COLOUR IS AIRBRUSHED

When you work freehand with the airbrush, you may find it difficult to get any impression of space and form in your paintings, because the colour areas have no defined edges. This is why many airbrushed images are heavily dependent on masking techniques (see page 32). The line and wash technique shown here enables you to control the colour applications a little more closely than a fully freehand painting, but without masking.

The image is constructed as an ink-line drawing, which you can carry out with a dip pen and India ink or with fibre-tip pens. If you use fibre-tips, check that the ink from the pen will not dissolve under the airbrush spray.

Create the drawing quite freely with the pen, then airbrush in broad areas of colour to enhance the description of your subject. Using transparent watercolours or inks, you do not lose sight of the black line drawing underneath. However, you can add opaque colour for special effects (see page 31).

You may find it helpful to take several photocopies of your drawing. Then if you get something wrong, you can try again, or you can develop different colour schemes.

CREATING A MOOD

This technique is suitable for all kinds of subjects. A landscape drawing can be made more atmospheric with a careful build-up of tones and textures. You can overspray adjacent areas to blend the colours, or work close to the surface to fill in particular shapes. As with traditional watercolour technique, it is often effective to leave some white paper showing through the colour to highlight the image.

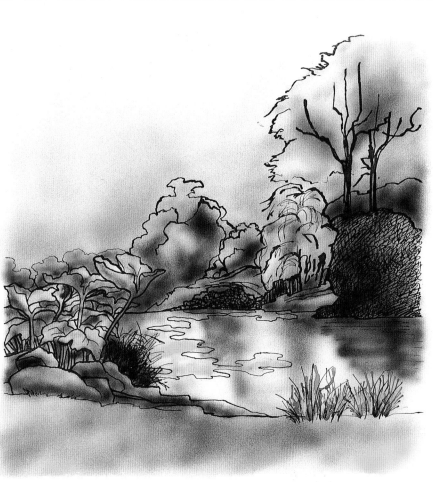

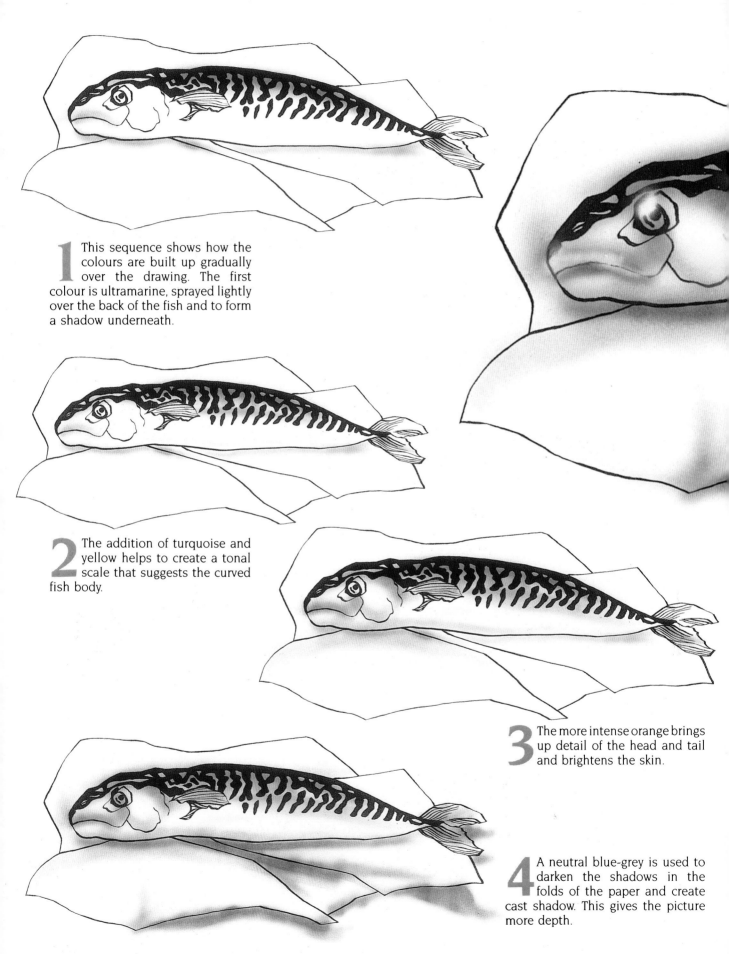

1 This sequence shows how the colours are built up gradually over the drawing. The first colour is ultramarine, sprayed lightly over the back of the fish and to form a shadow underneath.

2 The addition of turquoise and yellow helps to create a tonal scale that suggests the curved fish body.

3 The more intense orange brings up detail of the head and tail and brightens the skin.

4 A neutral blue-grey is used to darken the shadows in the folds of the paper and create cast shadow. This gives the picture more depth.

5 The smooth, glistening surface of the fish skin is simulated by laying down highlights in opaque white. White is also used to soften the shading of the paper.

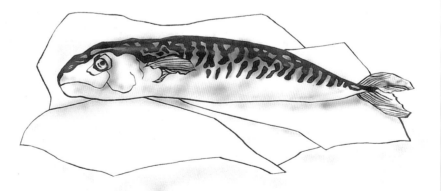

COLOUR VARIATIONS

Using several photocopies of your original drawing, you can try out different colours either to obtain variations of the naturalistic effect, or to produce a simply decorative rendering. For the fish below, the colours used were sepia, ultramarine, scarlet and orange; the one on the right is coloured with turquoise, magenta and orange, with a light dusting of black to deepen the mid-tones.

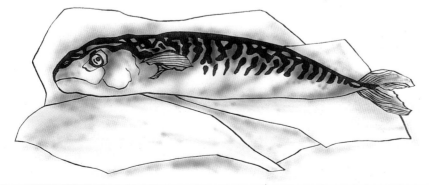

THE PRINCIPLES OF MASKING

AS YOU HAVE FOUND FROM THE PREVIOUS EXERCISES,
YOU CANNOT FULLY CONTROL THE EXTENT OR TEXTURE
OF SPRAYED COLOUR WHEN WORKING FREEHAND.
MASKING PROCESSES ENABLE YOU TO ORGANIZE YOUR
AIRBRUSH RENDERINGS MORE DELIBERATELY

A mask is any material that can be placed between the source of colour – your airbrush – and the surface that the coloured spray is falling on. The mask receives the spray, leaving the area of paper beneath it free of colour. Masking materials and techniques provide your means of defining edges and shapes, and of making random or regular textures and patterns.

In the following chapter, all the different kinds of materials and their uses are explored in more detail, with examples and projects that you can adapt to your own style of work. The samples on these pages demonstrate the basic principles of masking, for creating negative or positive shapes and particular edge qualities.

Materials that are laid freely on the working surface, which include pieces of paper and card, stencils and pre-cut templates or fabrics and found objects (pages 40-51), are called loose masking. Hard masking materials are those that actually adhere to the surface, such as adhesive tapes and labels and purpose-made masking film (pages 58-75).

One important basic principle is that the more tightly the mask clings to the surface, the harder the edge of the masked shape. This is why masking film is mainly used for detailed graphic work. With a loose mask, if you raise it from the paper some spray drifts underneath, so the image is softer.

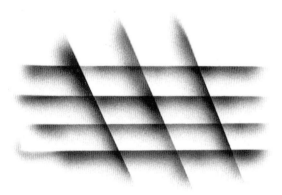

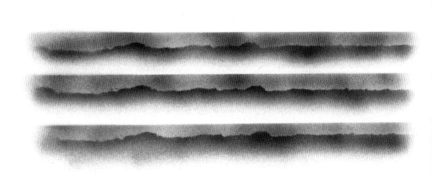

LOOSE PAPER MASKS
These bands of colour and the simple grid are made by spraying along the edges of paper strips. Torn paper gives a rough edge, cut paper a clean edge.

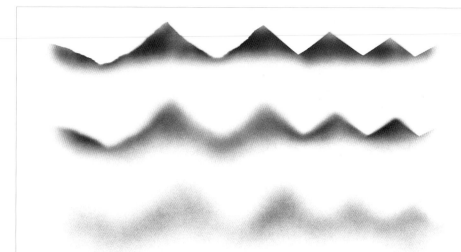

In this example, the paper strip that forms the mask is progressively lifted further from the working surface. You can see how the edge gradually becomes less distinct.

FORMAL SHAPES

A pre-cut template also acts as a stencil mask. This is the tip of a plastic French curve with inset ellipse cut-outs.

SILHOUETTES AND VIGNETTES

A mask can surround the image area, resulting in a positive, silhouetted shape (top), or it can cover the central image, allowing the spray colour to fall on the background area only. These effects can be obtained with simple paper or cardboard stencils, or masking film.

FOUND MATERIALS

Some fabrics have a texture that is loose enough for sprayed colour to pass through. This weave-pattern comes from spraying through openwork tapestry canvas.

PROJECT: LANDSCAPE

A SIMPLE PAPER MASK IS USED TO SEPARATE LAND AND
SKY, BUT THIS PROJECT MAINLY RELIES ON FREEHAND
AIRBRUSHING TO CREATE SPACE AND TEXTURE
IN THE LANDSCAPE

A broad landscape view enables you to work quite freely building up colour and texture. You draw the basic structure of the composition with linear spraying, keeping the airbrush nozzle close to the paper. You can then pull back to spray in the areas of graded colour.

Start by cutting a paper mask that follows the line of the hill and the horizon. If you make one clean cut, you have two pieces of paper representing the curve of the land in positive and negative form. Use the positive mask to cover the blank paper while you spray the blue sky right across the background. Then you can use the negative mask to cover the sky while you outline the landscape. Having established a clear division, you can continue working freehand.

To achieve the dense, dark tones of the hedgerows and foliage cover on the hillside you need to build up the picture gradually, overlaying one colour on another. The demonstration is painted in watercolours on a thick, lightly textured watercolour paper. You will find that the colours lighten as they dry, so it takes some time to develop the darkest tones.

Because watercolours are transparent, you must progress from light to dark, preserving the areas of pale colour by spraying around them. Over the page, you can see an example of the same landscape painted in gouache, which can be worked light over dark and gives a different kind of surface finish.

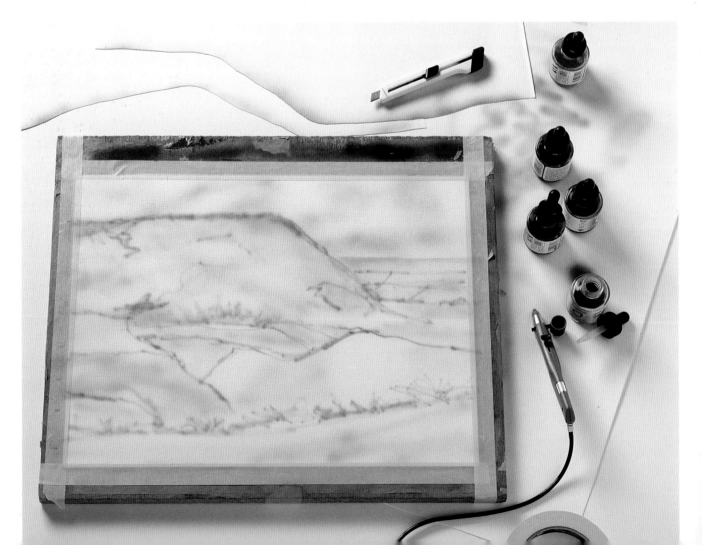

1 Lay the positive mask on the paper and spray along the top edge with blue, varying the density of colour to suggest space and depth in the sky. When it is dry, lay the negative mask over the sky and airbrush the lines of the hilltop and horizon with green. Sketch out the shapes of the hillside and fields. Indicate the lightest colour areas by spraying with yellow, but use blue towards the horizon to convey distance.

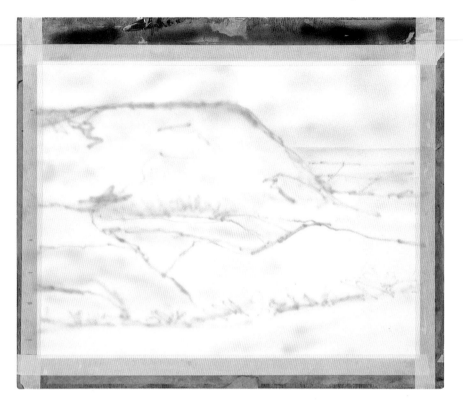

2 Gradually fill in more of the picture, keeping the spray pattern light at this stage. Add brown to your colour range, as shading on the hillside and to draw the lines of the ploughed field in the middle ground.

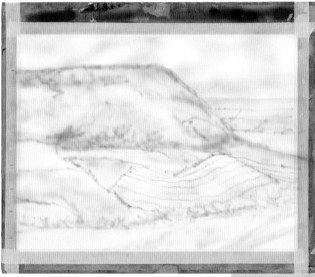

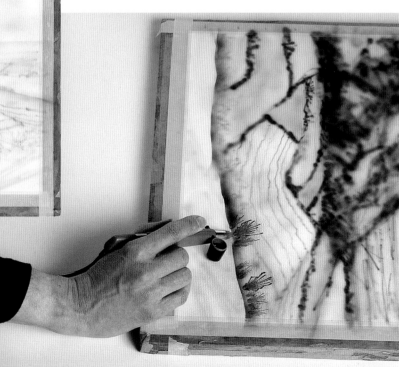

EQUIPMENT
- Airbrush and air source
- Watercolour paper
- Liquid or tube watercolours
- Cartridge paper for masking
- Craft knife
- Masking tape

3 Work with blue and a darker green to develop more complex textures in the foliage. To make the spiky pattern of the shrubs in the foreground, put the airbrush nozzle down on the paper and spray heavily so the colour blows into spidery blots.

4 Gradually intensify all the tones and colours to enhance the shapes of the landscape and develop the impression of space and distance. Spray the warm brown into some of the darker areas, to contrast with the cool blues and greens. At this stage, you need not use the mask when working close to the upper outline – a free edge makes a more natural impression – as long as you control the spray angle and extent.

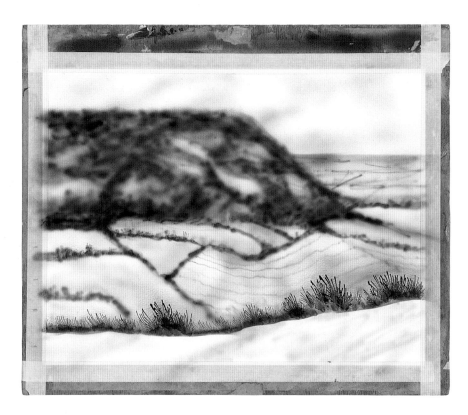

5 In the final stages, check the balance of shapes and tones and adjust the colours as necessary. Make sure there is a contrast between bright, sharp colours in the foreground and blued, hazy tones on the horizon, which helps to establish distance in the landscape.

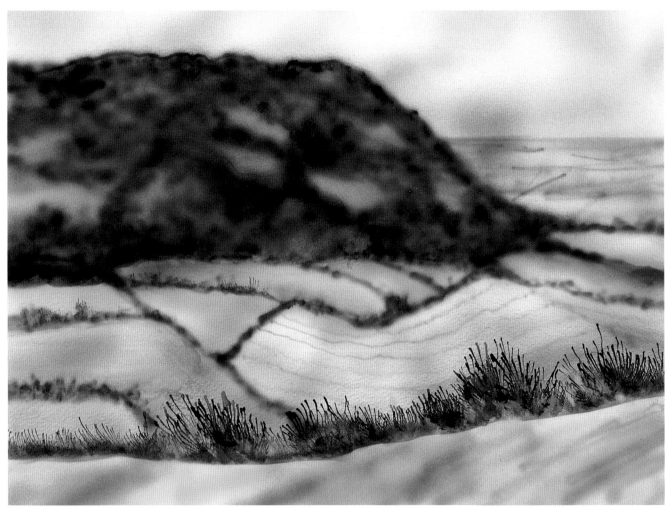

PAINTING WITH GOUACHE

Gouache is a naturally opaque medium, due to white pigment mixed with the colours during paint manufacture. The colours are less brilliant than water-colours, but gouache gives the advantage that light colours can be sprayed over dark tones, so you can correct or alter your painting at any stage.

Straight from the tube, gouache is a thick, rich medium. To make it a suitable consistency to pass through the fine airbrush nozzle, you must mix it with water in the palette until it has a smooth, milky texture. Brush it out carefully, to break down any lumps of paint that might clog the airbrush or disrupt the even spray pattern. Load the diluted colour into the airbrush cup using a soft sable or synthetic hair paintbrush.

This version of the landscape is sprayed in the same manner as the watercolour example, using graded tones and textured colour. But the patches of light tones on the hillside have been reworked over the darker colours, using a small torn paper mask to outline the shapes, then softening the edges of the masked shapes with freehand spraying.

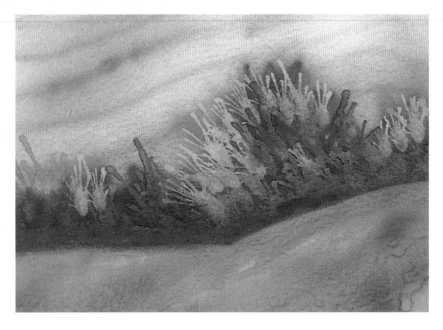

Foliage texture The density of the paint gives the blown strands of colour distinct edge qualities.

The balance of tones builds a pattern of light and shade.

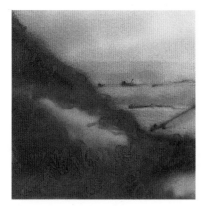

Space and distance Thin colour layers at the horizon distance the flat landscape from the dark edges of the hillside.

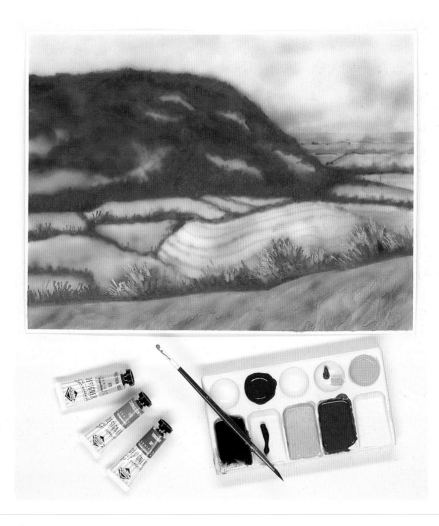

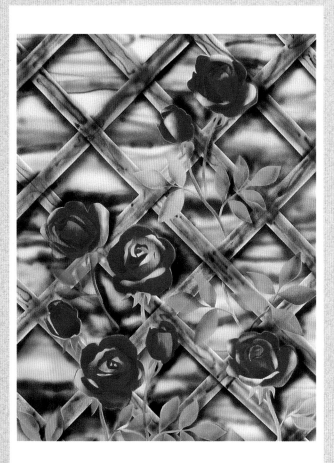

3

AIRBRUSH PAINTING

This chapter introduces a variety of airbrushing and masking techniques, alternating with full projects that show you how to achieve increasingly complex airbrush paintings

CUT AND TORN PAPER

PAPER IS A VERSATILE AND INEXPENSIVE MASKING MATERIAL,
WHICH YOU CAN USE IN A VARIETY OF WAYS TO BUILD
UP ILLUSIONS OF SPACE AND FORM

Strips of paper, cut or torn, create variable edge qualities to broad areas of sprayed colour. Layout or tracing paper is adequate for masking, but as these are thin materials, the edges rapidly become soaked with colour: a thin paper mask has a limited life. Heavier papers and card give different edge qualities according to their texture – the way they tear – and thickness. A thick material 'overshadows' the paper it is lying on and softens the edge.

A paper or card mask can be laid flush with the working surface or held at any distance above it. Experiment with straight and curved edges, both cut and torn. Making some test sheets of different effects gives you a repertoire that you can select from for suitable applications in finished artwork. It is also good practice in angling the airbrush correctly in relation to the mask and obtaining the right spray quality for solid or graded colours.

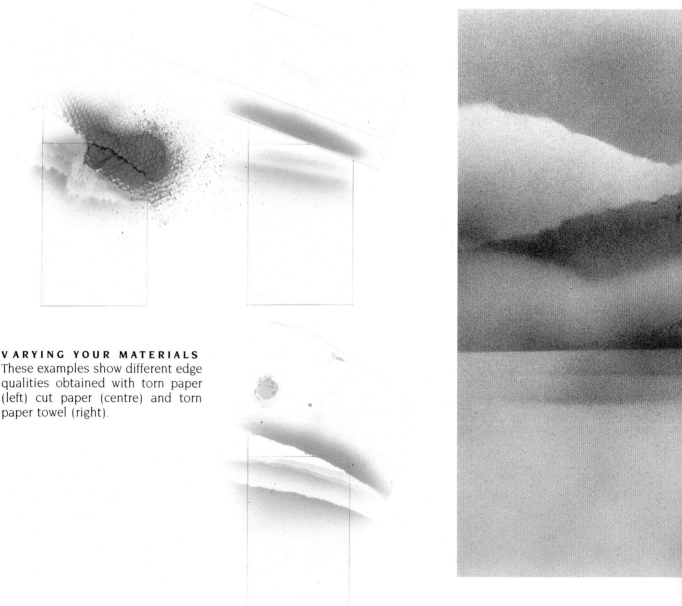

VARYING YOUR MATERIALS
These examples show different edge qualities obtained with torn paper (left) cut paper (centre) and torn paper towel (right).

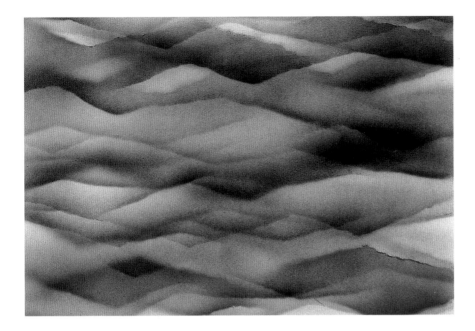

FORM AND DEPTH
This wave-like texture comes from two torn paper strips, overlapped at random. The illusion of space and form comes not only from the edge qualities of the shapes but the range of colours that you choose. You need to develop variations between light, middle and dark tones to give depth to the picture.

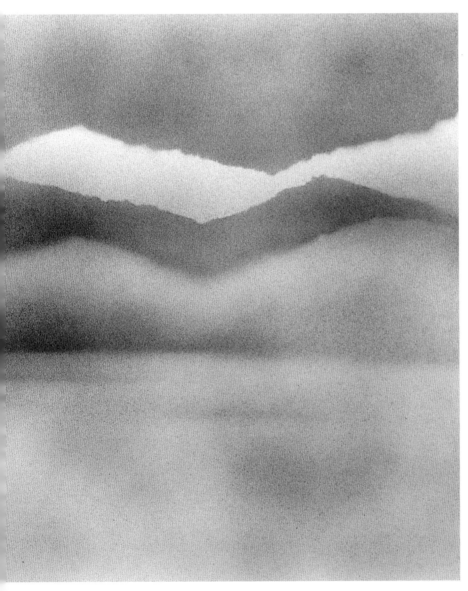

PICTORIAL SPACE
You can rapidly build up a landscape effect using simple paper masks. The mountain tops were torn into one side of a broad strip of paper, the opposite edge was left straight. The layering of the image was created by moving the mask up or down and from side to side, spraying different tones and colours across the top and bottom edges.

Practical tip
Because paper masking is so easy, it is tempting to build up layers of colour very quickly. Be careful not to lay a mask on still-wet colour areas, as this can cause nasty smears that will always stand out from the finer spray texture.

FOUND OBJECTS AND MATERIALS

ALL KINDS OF MATERIALS GIVE INTERESTING AND UNUSUAL
EFFECTS WHEN USED AS LOOSE MASKING, INCREASING
YOUR REPERTOIRE OF AIRBRUSHED TEXTURES

As the basic function of a mask is simply to prevent the airbrush spray reaching the paper, the materials you use for masking do not have to be purpose-made art materials. Avoid anything very lightweight, which can be blown away by the air pressure, or highly absorbent, which will let colour soak through too quickly on to the paper. Otherwise, there is a wide range of common items you might try.

Soft materials like crumpled kitchen paper or a pad of cotton wool produce gentle edge qualities – cotton wool is often used for masking cloud shapes. Coarse, open-weave fabrics make interesting meshed textures; paper cake-doilies or fabric braids form delicate lacy patterns. For random textures, you can scatter rice or lentils on the paper and spray over them, or use small objects such as push-pins or paper clips. Real leaves or leaf sprays are ideal for natural foliage patterns.

Test out some textures and shapes, using anything that seems suitable as a mask. Then think about the scale and density of the spray patterns you have made and how they might be applied to representing particular textures in your artwork.

IRREGULAR TEXTURES
All kinds of loose materials make interesting random textures: these examples show nails (top left), push pins (below left), split peas (top right), rice (below right).

LEAF SPRAYS
The effect you obtain with leaves and twigs depends on the scale and complexity of the original material. Because the leaves do not all lie flat, some of the spray drifts underneath and creates 'ghosted' shapes. In these examples, sepia spray etched the pattern in dark tone. The yellows and greens were applied to the monochrome image after the leaves were removed.

PRE-CUT PATTERNS
Something with a strong pattern quality of its own, like a cut-out paper doily, reproduces very accurately in the sprayed version.

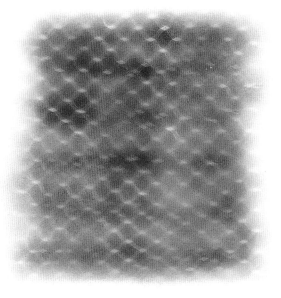

MESHES AND NETS
This delicate trellis pattern comes from a plastic net bag used as packaging for onions. The net was stretched over the paper and sprayed first with yellow, then moved slightly across and resprayed with purple.

PROJECT: CLOUDY SKIES

Dramatic cloud studies like this are surprisingly simple to produce using only the most basic masking techniques. The combination of cardboard templates and loose cotton wool creates the solid shapes and misty trails. It is easiest to use cotton wool on a roll, rather than pre-formed pads or balls, so you can pull out the amount you need and shape it with your fingers. Before you start a finished piece of work, you may need to practise thinning out the material or pleating and bunching it, and making quick test-sprays to see how the textures work.

The examples shown here demonstrate how to make the cloud shapes both negatively and positively. You can spray colour around the cotton wool, on white paper, so the masked areas appear in solid white. Or you can work on coloured paper with an opaque medium – acrylic or gouache – so that the colours you spray are the pale tones and the background provides the darker shades. Even simple monochrome spraying can be very effective, but to build up the mood and intensity of your study, you can vary your palette imaginatively, using browns, blues, purples and yellows.

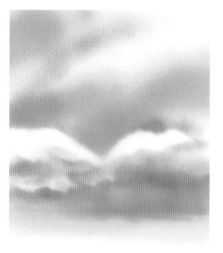

COTTON-WOOL MASKING
An ordinary pad or ball of cotton wool masks the airbrush spray completely, creating a silhouette with a relatively heavy, hard edge. To obtain a more sensitive outline and texture, you need to tease out the cotton wool and shape its edge.

OUT OF THE BLUE
These effects of piled, fluffy clouds or gentle drifts across a bright blue sky are all done by spraying around cotton-wool masks with transparent blue watercolour on white paper. As well as positioning the masks appropriately, it is important to vary the quality of the airbrush spray. You can do this by moving closer to the paper or further away, overspraying selected areas only, and changing the angle of the airbrush in relation to the masked edge.

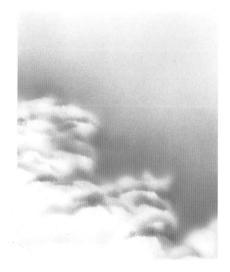

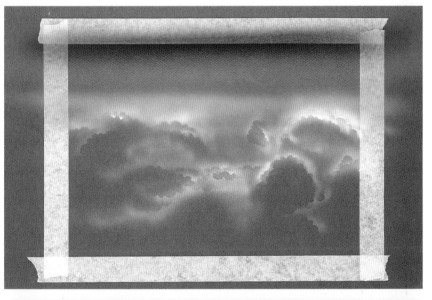

1 Prepare cardboard cloud templates with cotton wool stuck around the edges. Work on dark paper using opaque gouache as your medium. Begin by spraying with white tinged with red and a touch of black, so the white is warm and not too stark. Turn your templates to spray along the curves and straighter edges.

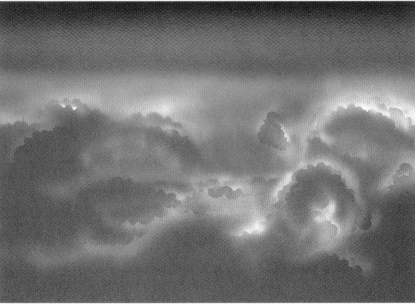

2 Build up the shapes by spraying with pure white and pale yellow. Check the balance of the light tones and soften them by overspraying as necessary with light drifts of white.

3 Strengthen the highlighting so that the clouds on the right-hand side appear very brightly lit. Spray freehand over any hard edges to bring back the atmospheric effect, but leave enough variation of tones and edge qualities to create some depth in the picture.

EQUIPMENT
- Airbrush and air source
- Dark-coloured Ingres paper
- Cotton wool
- Cardboard
- Craft knife or scissors
- General-purpose adhesive
- Gouache

HAND-MADE STENCILS

THE SIMPLE CRAFT OF STENCILLING PROVIDES A WAY OF MAKING LIVELY, EVEN COMPLEX IMAGES, IF YOU DRAW AND CUT YOUR OWN STENCILS

Stencilling is often associated with decoration of objects and materials, in interior design, for example. It is particularly useful for repetitive patterning, where one or two simple stencils enable you to colour whole shapes easily and quickly. However, stencils can be used in a more painterly fashion, not only for filling in shapes but to give some modelling to the forms.

You can make stencils from all kinds of sheet materials, including paper, cardboard and acetate. As paper tends to curl when wetted, it is best to use a more resilient material for stencils that are finely cut or subject to repeated spraying. Work out your drawing on tracing paper, then transfer it to the stencil material and cut out the shapes with a very sharp craft-knife.

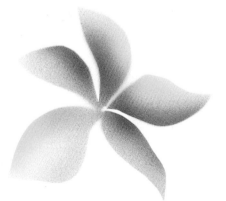

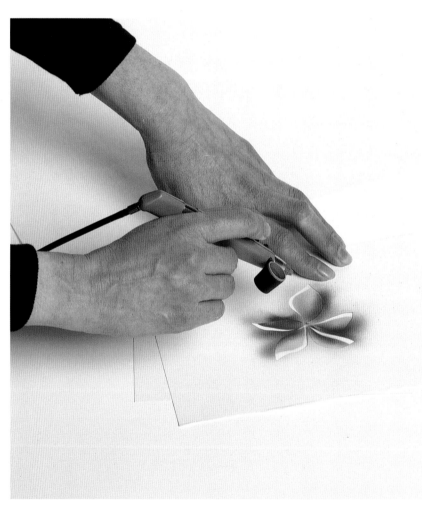

1 Cut the whole shape of the flower from a piece of stiff paper or thin cardboard. Spray first with the lightest colour, in this case yellow, grading the tones across the petals to give them shape.

2 With the stencil in the same position, spray with red, building up strong colour on one side of each petal and grading outwards to fade to yellow on the opposite edge.

3 Turn the stencil slightly to the left, keeping it centred on the flower. Load the airbrush with purple and spray against the top edge of the stencil on the left-hand and lower petals.

4 Put the stencil back to its original position and darken the outer edges of the other petals. The purple shading creates the impression of gentle curves.

5 To make the stamen at the flower centre, put the airbrush nozzle on the paper and blow out a spidery trail of wet colour. If you have a spatter cap, you can use this to add dark speckles on the petal tips.

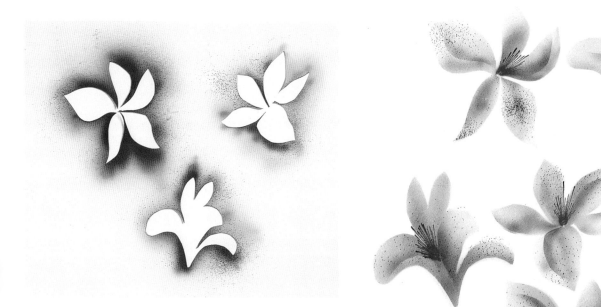

FLOWERHEADS
By varying the density of successive colours and moving the stencil into different positions for shading the flowers, you can obtain a variety of effects from a few basic templates.

PROGRESSIVE STENCILS

You can create detailed colour variations using only one stencil if you cut the sections in a progressive sequence, so that both colours and tones can be varied at each stage.

In these examples, the anemones were drawn in line and alternate petals of the red flower were cut out and sprayed. Then the remaining petals were cut and coloured; doing this in two stages gives the petals distinct edges where they overlap.

The purple flower was treated in the same way; then the stems were sprayed and, finally, the leaves, using variegated colours.

PRE-FORMED STENCILS

Many kinds of plastic stencils and templates are available from stationers and art suppliers, showing geometric shapes, figures, symbols and lettering. These can be used for airbrushing in exactly the same way as any other type of loose mask. Placing the stencil flush to the paper, you get a clean-edged impression. If you lift the stencil, the sprayed edges blur.

PROJECT: STILL LIFE

The important shapes in this example are the outlines and internal shapes of the jug and bowls. The strawberry pattern on the jug and the strawberries in the dish can be added once the basic forms are clearly rendered.

Draw up the composition on tracing paper and use the trace as a guide to cutting the stencils out of thin cardboard. To begin with, cut one stencil for the whole outer shape of the still life, representing the objects separated from their background. For each of the three objects in the group, you need a stencil of its whole outline and of the two internal shapes – the outer surface and the ellipse within the rim of jug or bowl.

Keep all sections of each stencil; the outline shape and the pieces you have cut out of it. As you build up the painting, you can tape the sections together in different relationships to mask off particular shapes.

EQUIPMENT
- Airbrush and air source
- Watercolour paper
- Thin cardboard
- Liquid watercolours or acrylic inks
- Tracing paper
- Scalpel or craft knife
- Masking tape

1 Position the full outline stencil on the paper and spray around it with black to shade the background. Use a strip of paper to mask the straight edge dividing the horizontal foreground plane and the vertical background. Then use the individual stencils for jug and bowls to model the shapes inside the outline.

Practical tip
It can be difficult to draw perfect ellipses freehand, for the interior shapes of the bowls. When one side of the ellipse looks right, trace it off on to cartridge paper, fold the paper and cut around the curve of the traced half-ellipse. When you unfold the paper, you have a symmetrical shape which you can use to correct your original drawing.

2 Reposition the individual stencils in turn to lay in the basic colours of the jug and bowls. Vary the density of the spray to create modelling and highlights.

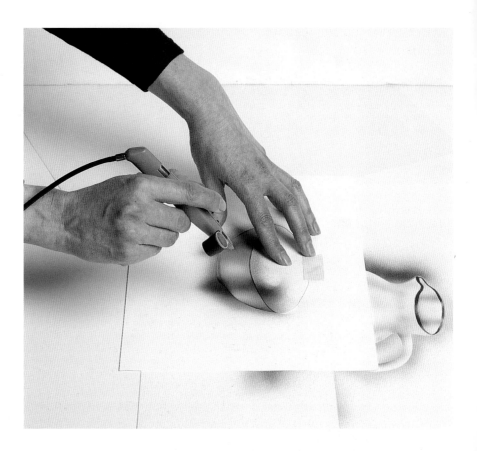

3 By moving the stencil sections, you can create shapes within shapes. The red rim on the jug was formed by attaching the internal shape to the outline stencil, first overlapping at the top, leaving a fine gap at the lower rim which was sprayed with red; then overlapped at the bottom, leaving a line exposed around the top edge.

4 Cut one stencil for the strawberry pattern on the jug and repeat the shape, spraying lightly with red. Mask off the main shape with the outline stencil while you do this. For the strawberries in the dish, cut two different-sized stencils, overlap the two shapes and put them at different angles to build up the heap of strawberries. Spray with red to establish basic shapes, then shade them with brown.

5 In the final stages, work on the balance of tones, so the shadows and highlights give emphasis to the shapes. Then add finishing touches like the strawberry stalks and the spattered, grainy texture inside the sugar bowl.

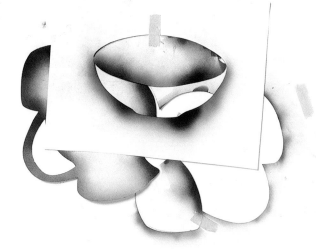

COMBINING THE STENCILS
You can see here how the internal ellipse of the larger bowl has been taped into the outline shape to mask off the green area only. As long as you keep all the pieces of the stencils, you can decide as you go along how to combine and position them to expose the right areas for spraying.

MASKING FLUID

MASKING WITH FLUID IS THE SAME IN PRINCIPLE AS USING
A PAPER MASK, BUT THE EFFECTS ARE QUITE DIFFERENT
AS YOU CAN PAINT THE FLUID ON VERY FREELY

Masking fluid is a liquid rubber compound which dries on exposure to the air. When painted on paper and allowed to dry, it acts like an adhesive mask, blocking out the shape and forming a hard edge against the spray area. After spraying, when the colour has dried, you remove the rubber mask by rubbing it gently with your finger or a soft eraser, or you can ease up the edge and peel back the rubber.

You need to test the adhesion of the fluid on the paper you intend to use, making sure it is easy to lift and does not tear up the paper surface. It will work best on a resilient surface, such as smooth illustration board or heavy watercolour paper.

You can build up layered textures by alternately masking and spraying, but the masking fluid sometimes dissolves the colour underneath. Acrylic inks are a more resistant medium for this than liquid watercolours. Let the colour dry completely at every stage, before applying or removing the mask.

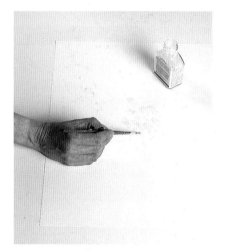

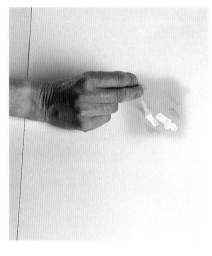

1 With an ordinary paintbrush, apply the masking fluid to the paper to form the shapes or texture you require. Wait until it is completely dry, then spray over with your first colour.

2 Lift up the edge of one piece of the rubber mask and peel it gently back from the paper. Clear all the shapes in the same way. You can use a soft eraser to pick up any small bits and pieces that get left behind.

3 The effect of the first stage of masking is to leave white shapes clearly outlined within the colour area. By repeating the whole process to apply a second and third colour, you can develop a more complex texture.

Practical tip
If you are removing dried masking fluid by rubbing with your fingers, you will get a build-up of colour on your fingertips. Keep damp and dry tissues beside you so you can clean your hands frequently, to avoid making smudges and smears.

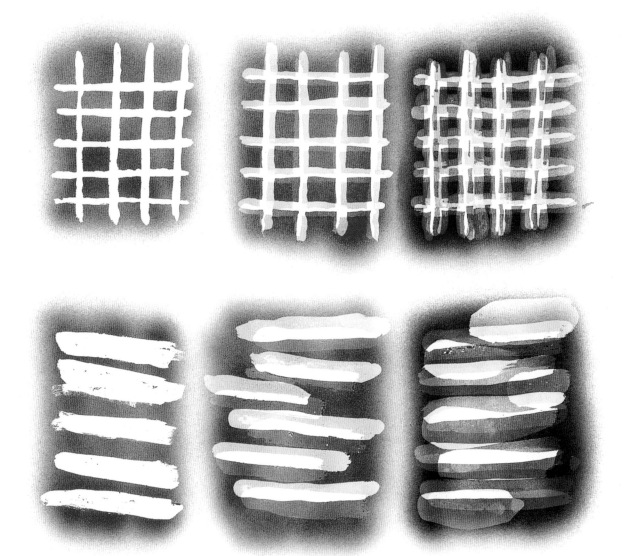

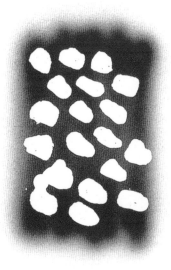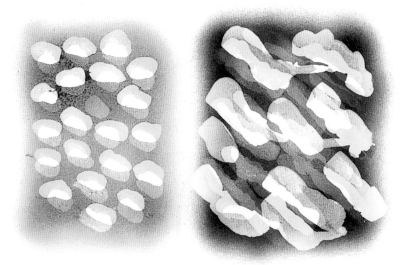

VARYING THE TEXTURES

You can create coarse or fine textures, depending on the kind of brushstrokes you use when applying the fluid. Try to plan the colour sequence to build up an interesting combination of harmonious or contrasting hues and tones.

PROJECT: FLOWER GARDEN

**THIS PAINTING TAKES AN OPEN APPROACH TO THE SUBJECT,
USING FREEHAND SPRAYING AND MASKING FLUID TEXTURES
TO PRODUCE A COLOURFUL, IMPRESSIONISTIC IMAGE**

The shapes and colours of this flower garden painting are based on a simple line layout, but the composition is very loosely interpreted. You will get the most interesting result with this kind of work if you allow the image to evolve freely from the techniques you apply.

Paper masks cut from photocopies of the original drawing are used to define the general shapes and shadow areas. Much of the colour is sprayed freehand to develop tone and texture.

The colourful flower borders are masked while the greens are built up in repeated overspraying. Then the bright hues are sprayed in textured layers, using masking fluid to create simple, irregular patterns.

This can involve reworking the same area of the painting two or three times, so the surface you paint on must be resilient. Either a heavy watercolour paper or smooth-finished illustration board is suitable.

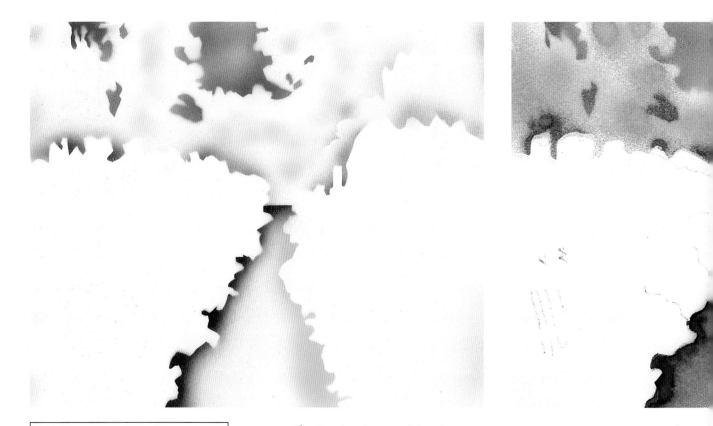

EQUIPMENT

- Airbrush and air source
- Watercolour paper or illustration board
- Acrylic inks
- Masking fluid
- Fine paintbrush
- Photocopy masks
- Scalpel or craft knife

1 Cut the shapes of the sky areas and path out of one photocopy. Spray the sky with blue, the left-hand edge of the path with sepia, and the right-hand edge with yellow. Cut the background shape out of the second mask and shade the top edge lightly with sepia. Then spray yellow freehand into the foliage area.

MAKING PAPER MASKS

You can attempt a composition of this kind by spraying the shapes directly on your paper, but if you are still developing your skill with the airbrush it is helpful to work from a basic layout.

Draw the general shapes of the various elements – sky, foliage, flower borders and path – in outline only. Take several photocopies for use as loose masks, leaving a border area all around the drawing. Cut out different sections of the photocopies according to the areas you are colouring at each stage.

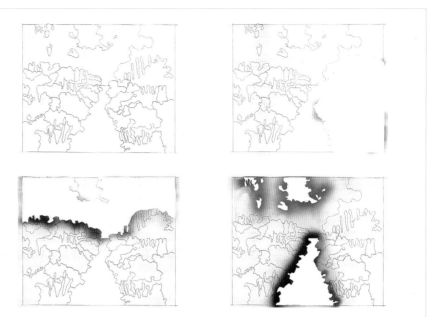

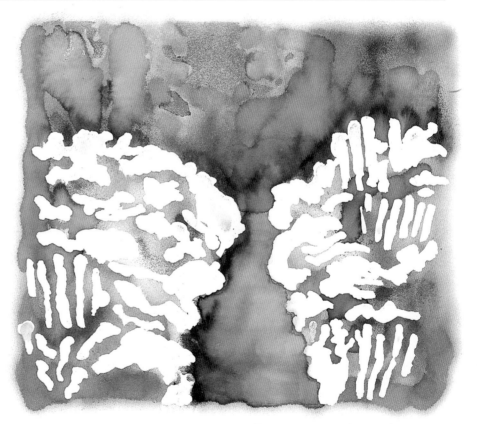

2 Use the first mask again to spray bright green over the grassy path in the foreground of the painting. Apply the second mask to work the same colour across the background, spraying freehand around the blue shapes. Shade and darken the foliage with sepia and deep green.

3 Refer to your original drawing and block out the basic shapes of the flower masses by painting them with masking fluid. Let the fluid dry completely, then overspray with green, blue and warm brown to darken the shapes between the flowers. Use the same colours to darken the background. When the ink has dried, rub off the masking fluid to reveal the white shapes.

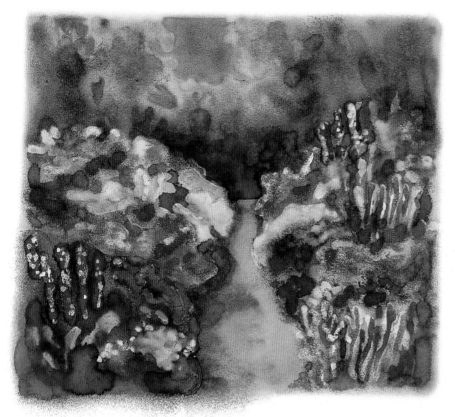

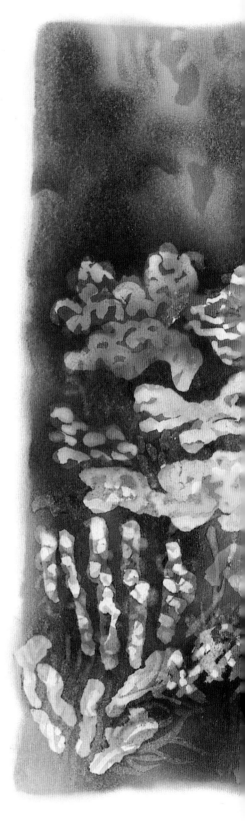

4 Put textural detail into the flower shapes with dots and dashes of masking fluid. When it is dry, spray the colour areas freely, creating patches of bright, varied hues. Use blue, yellow, orange, red and purple, with small touches of green in the extreme foreground.

Practical tip
Masking fluid applied over a sprayed area sometimes bleaches out the colour. The dried fluid may also pull up the paper surface as you remove it. Using a hairdryer to dry the colours or the masking fluid thoroughly at every stage seems to reduce the risk of either problem occurring.

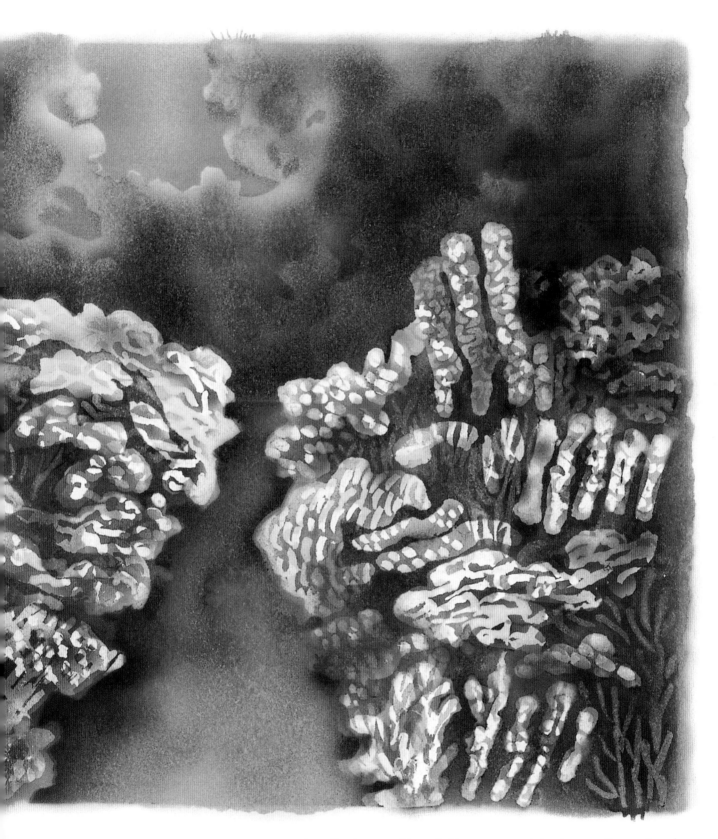

5 Rub off the masking fluid textures and repeat the process of step 4 to develop more complex textures and colour overlays. You may be able to do this a third time in some areas, but take care not to damage the surface by overworking. You can also put some additional texture into the greens, as the colours usually lighten a little when they are overpainted with masking fluid.

ADHESIVE TAPES AND LABELS

THESE READY-MADE MATERIALS ARE USEFUL FORMS OF HARD MASKING FOR STRAIGHT EDGES, REGULAR GEOMETRIC SHAPES AND REPEAT PATTERNING

Self-adhesive tapes and pre-cut paper shapes are easy to use as masking materials, provided the adhesive is low-tack and lifts from the paper or card that you are painting on without damaging the surface. The grip of the adhesive varies between products, and also acts differently on different surface finishes. Thin or very fibrous paper, for example, may tear when you pull off tape, whereas heavy watercolour paper and smooth card are more resilient. It is important to test the easiness of applying and lifting the tapes or labels on the particular surface before you try to use them to create a finished piece of artwork.

Masking tapes with low-tack adhesive are available in various widths. A broad tape enables you to mask straight lines and regular hard-edged shapes. Thin tape, 8mm (¼in) or 12mm (½in) wide can be manipulated around shallow curves. Some types of lighter-weight transparent tapes of the kind sold for office use will function similarly, but not all of these are low-tack because they are not intended for masking.

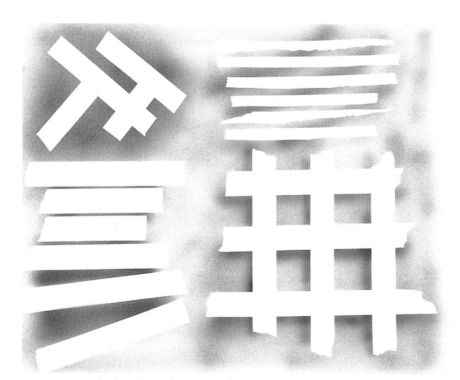

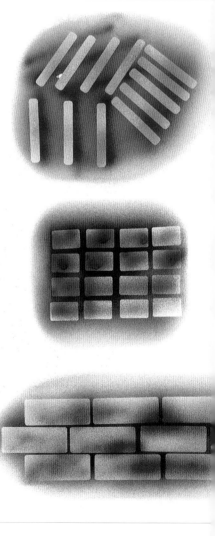

LINES AND GRIDS
Masking tape applied flat can be used to make regular or irregular stripe patterns or to suggest three-dimensional structure. By varying the tone of the sprayed colour, you can create depth and shadow behind the masked shapes.

THREE-DIMENSIONAL DEPTH

Tapes can be used in similar ways to paper masks or card stencils to develop textures or solid forms. The advantage of using tape is that you don't have to hold down the mask while spraying – it stays in place and no colour can drift underneath, so it makes a clean, hard edge to the sprayed areas. You can build up colour layers with flat or graded tones, re-masking as necessary to produce overlapping and angled shapes.

PRE-CUT ADHESIVE TAPES

Sticky labels are useful for masking repetitive shapes and patterns – regular circles, rectangles and stripes or fancy shapes such as stars and crescents. Labels are likely to be more firmly adhesive than purpose-made low-tack tapes, so don't rub them down too hard. If they are difficult to lift with your fingers, use the tip of a knife blade to ease up the edges. It is often safer to work all around the shape and peel it gently inwards, rather than pull it up from one side in a single motion.

HARD AND SOFT EDGES

This gentle rippling effect (left) comes from twisted strips of masking tape. Twisting it means that the tape's folds and edges are at different levels in relation to the paper surface, so you get variations between hard and soft masking.

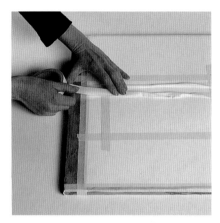

1 Mask off a rectangle with strips of tape laid flat on the paper to form a 'frame' for the spray area. Pull out another strip from the roll and stick it to the top edge of the frame about 2cm (¾in) from the adjacent side. Twist the tape randomly and attach it to the lower edge of the frame. Repeat at intervals across the rectangle.

2 Spray your first colour between the tape strips, running the airbrush consistently from top to bottom to obtain even coverage. Peel off the strips to reveal the irregular pattern.

3 When the colour is dry, make a second application of twisted tapes in the same way as before, positioning them so that they partially overlap both the red and white bands.

4 Spray the second colour over the whole image area. Allow it to dry and then peel off both the twisted tapes and the flat tapes on the outer frame. The effect of this technique is different every time.

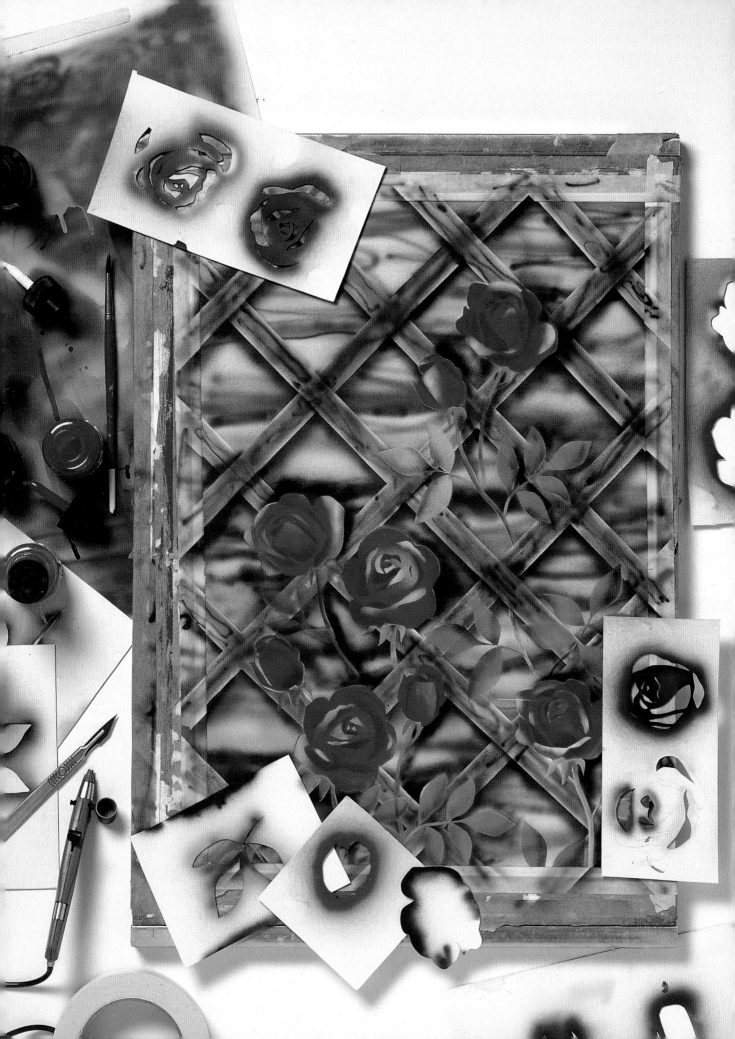

PROJECT: ROSE TRELLIS

THIS COMPOSITION ATTRACTIVELY COMBINES THE HARD-EDGED GEOMETRIC PATTERN OF THE TRELLIS WITH THE ORGANIC SHAPES OF THE ROSES AND LEAF SPRAYS, USING A COMBINATION OF MASKING AND SPRAYING TECHNIQUES

Masking tape forms the basic framework of the picture, applied as crossed strips that outline the trellis cleanly against the background. The textures of the trellis and the wall behind are sprayed freehand in line and graded colour. This technique is combined with spraying through card stencils to shape the roses, stems and leaves.

There are eight roses in the picture, but only three basic shapes are used – a bud, a partially open rose and a full bloom. For each rose, there are three individual stencils cut from card – the whole shape, the shadow areas and the highlights. You need to prepare these beforehand. Similarly, for the stems and leaves, there are only three master stencils. You can

make them seem more varied by positioning them differently in relation to each rose or spraying through only part of the shape.

Save the pieces cut out of the card stencils as well, for creating cast shadows (see step 10) and adding colour accents.

Using acrylic inks, which are relatively transparent, you can do the close freehand work on the trellis without overlaying colour noticeably on the background. But to make sure the colours of the roses come up bright and clean against the background, you spray each whole shape with white ink before applying the petal colours. This is easier than planning a more complex masking sequence to leave the flower shapes unsprayed from the start.

EQUIPMENT

- Airbrush and air source
- Smooth white artboard
- Cardboard for stencils
- Acrylic inks
- Masking tape
- Tracing paper
- Scalpel or craft knife

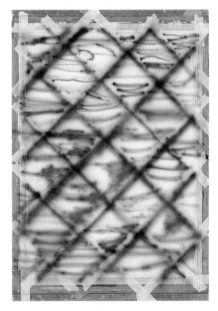

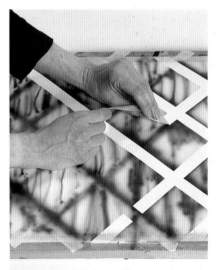

1 Apply a diagonal grid of masking tape strips to the paper to form the trellis pattern. Spray loosely over the whole image area with black lines and graded tones of black and yellow, to create a stone-like texture representing the wall. Spray black evenly along the lower edges of the tape strips, to suggest shadowing behind the trellis.

2 When the colour is dry, peel back the tapes to reveal the clean grid pattern. To avoid tearing the paper surface, ease up the tapes from side to side at the edges as you go along and peel them away gradually, rather than pulling them straight back.

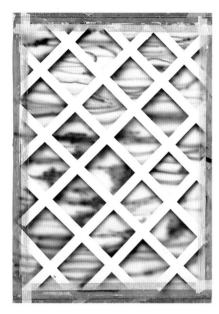

3 You can now see the exact result of the freehand spraying. It doesn't matter if the trellis pattern is a bit uneven, as this looks more natural than a perfect geometric grid.

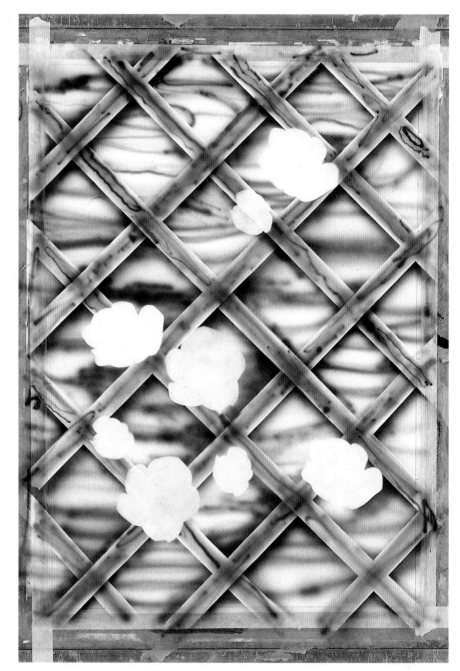

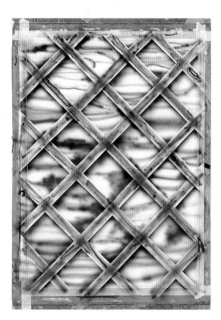

4 Using black ink, spray fine lines, keeping close to the surface, to create a wood-grain texture on the trellis. At the same time, you can enhance the shadow areas where the strips cross each other and in the cast shadow underneath. When the texture is complete, apply graded tones of light brown to fill in the shapes.

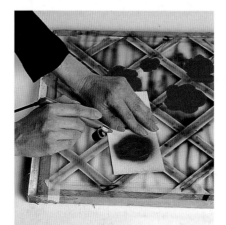

5 Acrylic inks dry quickly, so you do not have to wait long between stages. Take your stencils for the whole shapes of the roses and position and spray them one by one with white ink, building up the colour until it is opaque.

6 When the white ink has dried, spray each rose shape with bright red, using the same stencils. Then use the more detailed stencils to shade the folds of the petals with purple.

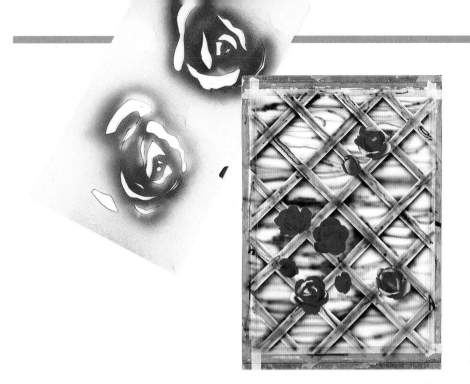

7 In the same way, use your remaining pre-cut stencils to apply highlights to the flowers, in white ink tinted with orange. You now begin to see the fully three-dimensional effect of the rendering. This is the basic principle by which you continue work on developing the flowers and leaves.

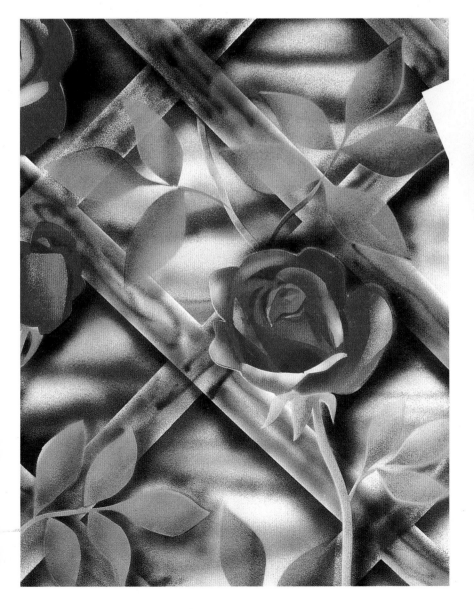

8 When you come to paint the leaves, it is not necessary to spray through every stencil with white before colouring. You might do this for the leaf sprays that come forward from the trellis and catch the light, but for those that are in shadow, you can spray greens and yellows directly over the background, gradually building up the colour until it is fairly opaque. This gives a more realistic range of tones.

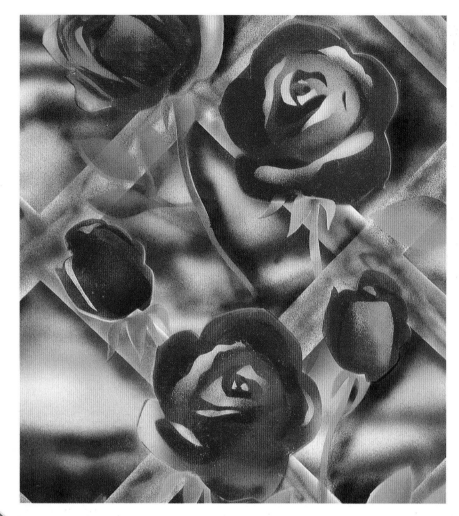

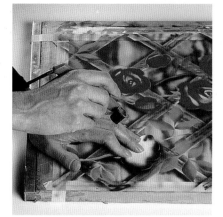

10 As a finishing touch, use the inner sections cut out of the stencils to mask out the flowers and leaves while you spray black around one side of each shape to deepen the cast shadows. This adds to the three-dimensional depth of the picture. You can also strengthen shadows behind the trellis at this stage, using the straight edge of a piece of paper as your mask.

9 To avoid making the flowers look too uniform, you can vary the pattern of light and shadow on the petals. In the two full-blown roses in this section, the detail stencils have been reversed, so the shadow areas in the upper rose become highlights in the lower one. You can also spray through only parts of each stencil to create more complex detail.

11 The simple techniques used in this project contribute to a colourful and sophisticated result. Because you do not have to fix any element from the start, you can develop your interpretation quite freely as you move through the stages, and re-use the stencils to make adjustments where necessary.

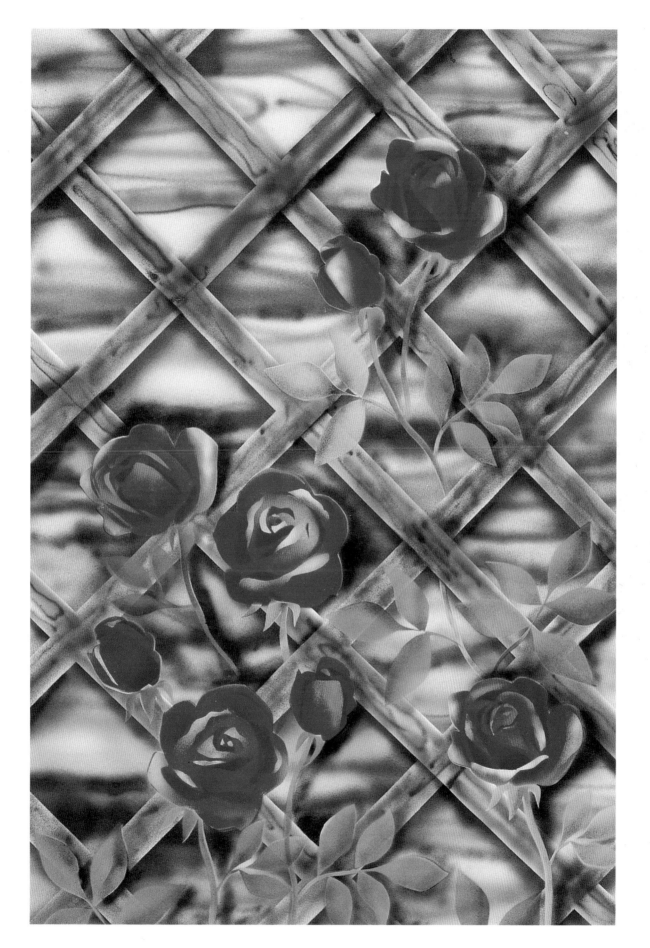

MASKING FILM

MASKING WITH TRANSPARENT FILM IS THE BASIS OF THE
DETAILED, GRAPHIC AIRBRUSH WORK THAT YOU SEE IN
ILLUSTRATION AND ADVERTISING, ALLOWING TOTAL CONTROL
OF THE EXTENT AND DENSITY OF COLOUR AREAS

Masking film is a self-adhesive, transparent plastic film specially developed for airbrushing. It adheres smoothly and tightly to the paper surface but peels away easily because its adhesive is low-tack.

The principle of film masking is simple. You cut a piece large enough to cover your image area with a border on all sides, lay it down on the paper by the method shown below, then cut out the shapes you want to spray when the film is in place. If you use a very fine scalpel for cutting, it is possible to slice through the thin film without heavily scoring the underlying paper. You lift out the cut section of the mask, and you are ready to spray.

The film is available with matt or shiny finish and is mounted on a waxy backing paper which you peel off as you lay the film. With the shiny finish it is easier to see what you have cut out, but you cannot easily draw on the surface, whereas you can with matt film. Both types are fully transparent, so you can follow traced guidelines on your paper or artboard very accurately when cutting.

You should smooth out any air pockets or wrinkles in the film as you lay it down. These may make it difficult to cut, or leave loose edges where colour can bleed under the mask. Rub the film down firmly as shown opposite, or pull the edge of a plastic ruler across the surface.

1 Tape down your paper or illustration board and trace your image on to the surface. Cut a piece of masking film large enough to cover the whole image area with a border on all sides. Peel one corner of the film away from its backing and position it over your paper.

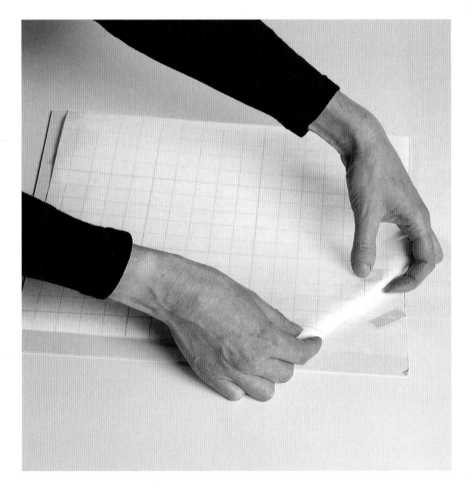

Practical tip
To avoid tearing the film or damaging the surface underneath, it is essential that you cut with a perfectly sharp blade and use a light touch. Buy a scalpel handle (usually available from artists' suppliers) and a set of disposable blades, and replace each blade as soon as it shows signs of becoming blunted.

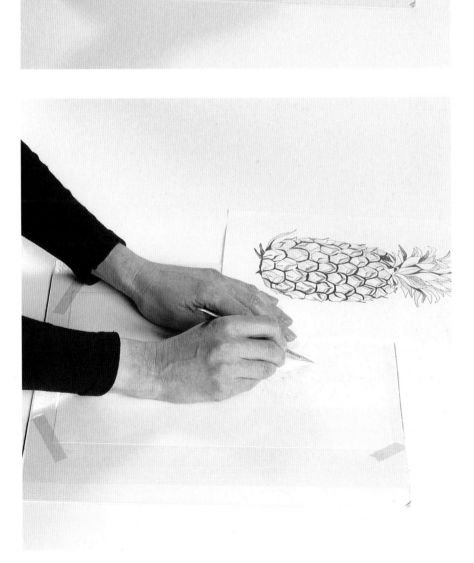

2 Fold a paper towel into a firm pad and lay it on the corner of the film. With your other hand, grip the backing sheet underneath the film and start to pull it away, smoothing down the film from above with the paper pad as you go. It is essential that the film adheres evenly, with no air bubbles trapped in it.

—

3 With the film in place, you can start to cut out sections of the image corresponding to the first colour you intend to spray. At first you will find it helpful to plan your colour sequence beforehand (the full development of this image is shown on pages 73-75).

4 Lift the cut sections by sliding the scalpel blade under the film and easing up the film edge until you can easily pick it up with your fingers. Then simply spray colour all over the surface.

PROJECT: PAVILION DOME

TO PRACTISE USING MASKING FILM, START WITH A STRUCTURED DRAWING AND PAINT IN MONOCHROME, WORKING OUT A PATTERN OF TONES THAT CREATES FORM AND DEPTH

Cutting and spraying through film is a methodical process. You need to have a clear plan of the image you wish to make. The usual practice for airbrush painting with watercolour or ink is to work from dark to light. Having put down the darkest tones, you can spray adjacent areas with progressively lighter tones without affecting the colour already laid down.

The most economical and ideal way of working is to use only one mask. The masking film is laid down over a line tracing, all the lines are cut, then the sections are lifted and sprayed in sequence – dark tones, medium, light. An experienced airbrush artist can also replace sections of the mask when necessary. However, this is quite a delicate process and you may find

it more efficient to remove the original mask and lay a fresh piece at certain stages.

Because masking film is non-absorbent, there is a build-up of colour on the surface that both obscures the image underneath and remains damp enough to be easily smudged on to the exposed areas of the artwork. Once this happens, it is advisable to renew the film. To avoid waste, you need not cover the whole image each time. If you have completed one part of the artwork, put film over the incomplete section only and mask off the rest of the image with paper. Leave enough of the sprayed area visible through the borders of the film mask to enable you to match the tones you have previously sprayed.

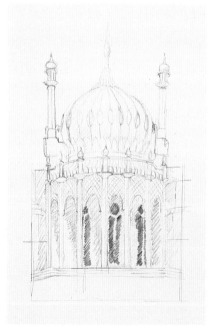

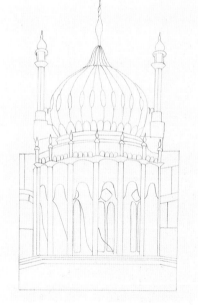

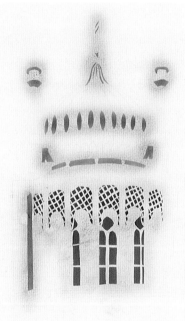

PREPARING THE IMAGE
The technique of film masking necessarily produces a tight, hard-edged style of image. You can pre-pare a working drawing quite loosely, as in the sketch shown here, but you must then take a tracing which gives you firm guidelines for

mask-cutting. With an architectural image like this, the lines and angles have to be made more regular than in the sketch, otherwise the finished painting will look incorrect rather than stylized.

1 Trace down the image and cover the working surface with masking film, as shown on pages 68-69. Cut all the shapes that should appear solidly coloured with dark tone. Spray the exposed sections of the artwork, building up gradually to the required tone.

2 Start working on the mid-tones at the top of the image, lifting and spraying the appropriate sections in turn. Make the segments of the dome by lifting one piece at a time and spraying against the masked left-hand edge of the shape, so the tone appears graded from left to right. Keep the lower part of the painting masked with tracing paper to avoid smudging the loose colour on the film surface.

3 When you have completed the upper section of the artwork, pull up the film and lay a fresh piece. Let the top edge of the mask overlap the base of the dome; cover the upper part with tracing paper. Continue working with the same sequence of tones in the same way. As long as you spray to a masked edge each time and keep working dark to light, the shapes will stay distinct.

EQUIPMENT

- Airbrush and air source
- Watercolour paper or illustration board
- Sepia watercolour or ink
- Masking film
- Tracing paper
- Scalpel

4 The finished painting has typical characteristics of film-masked airbrush work – clean, hard edges and smoothly executed tonal gradations creating an illusion of three-dimensional form.

PROJECT: PINEAPPLE

THE BASIC METHOD FOR COLOUR WORK WITH MASKING FILM

IS SIMILAR TO THAT OF THE MONOCHROME PAINTING, BUT

BY BUILDING UP THE SPRAY IN LAYERS YOU CAN OBTAIN

TONAL GRADATIONS AND COLOUR MIXES

This is an attractive subject for a colour rendering. The leaves and skin of the pineapple form a graphic pattern that enables you to plan the structure of your painting, but you can adjust the colour balance and shading in the final stages.

As before, you need to make a careful outline tracing as a guide to spraying. Plan the masking sequence to allow a fresh application of film for each colour element. In this example, the colours are worked from dark to light, as for tonal gradations. In your planning, take account of the fact that with transparent inks or watercolours, you can overlay colours so that they blend and modify each other.

For repeated cutting and remasking, you need to use a smooth, resilient paper or board, such as CS10 which is specially made for graphic work and illustration. A fibrous paper may be damaged by the repeated masking.

EQUIPMENT

- Airbrush and air source
- Illustration board or paper
- Watercolours or inks
- Masking film
- Scalpel
- Tracing paper

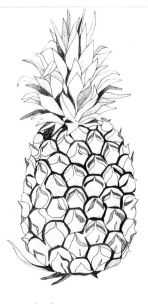

PLANNING THE COLOURS

When you have made a tracing of the outline design, take some photocopies and work on them with coloured pencils to plan the areas for spraying in each colour stage. Consider the balance of the colours individually, and the shapes on which they will blend and overlap. These drawings will act as your guide for cutting and spraying, but you can make different decisions if necessary while you are airbrushing, when you see how the image develops.

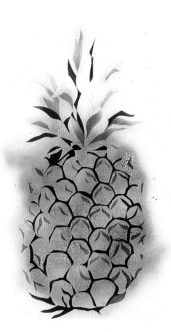

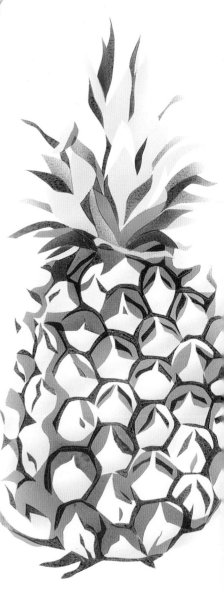

Practical tip
If you find when you remove the mask that you have missed a colour section at any stage, you do not need to remask the whole image. Put down a small patch of film on the immediate area and mask off the rest with paper while you cut and respray.

1 Trace down your drawing and apply masking film to the whole image area. Cut all the sections that will appear very dark or mid-toned in sepia. Lift the mask pieces from the areas for solid colouring and spray evenly. Then lift the film covering the mid-toned areas and spray more lightly.

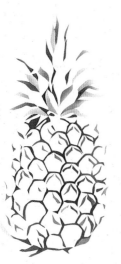

3 Put down fresh masking and repeat the process to cut and spray all the shapes that are dark green. You can spray over the sepia shapes where the colours overlap.

2 Peel off the masking film carefully, to avoid smudging colour from the film surface on to the artwork. It will not all come away in one piece. Lift small sections by picking up the edge with the scalpel blade until you can easily grip the piece of film between your fingers without touching the artwork. Check that you have not missed shapes.

4 Continue the same processes to apply the bright yellow-green. At this stage you can begin to see how the colours interact, although the shapes are still quite crisp and well-defined.

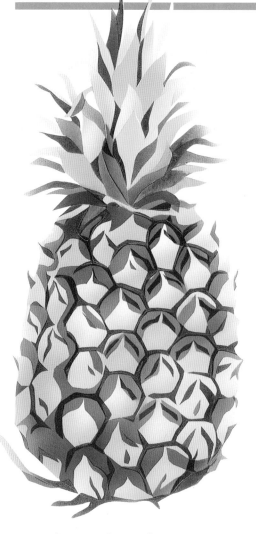

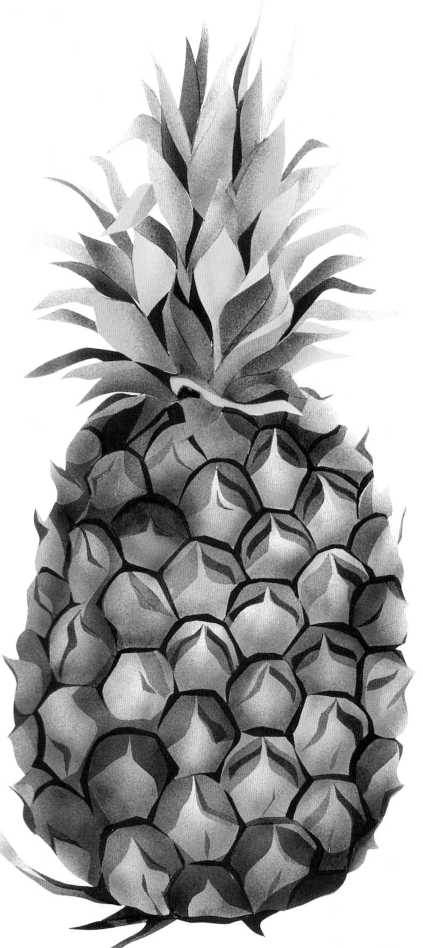

5 When applying the orange-yellow, you need to cut and spray the pineapple leaves individually. For the shading on the body of the fruit, you can unmask within the whole outline and spray freehand. The oversprayed areas now make subtle colour blends.

6 In the final stage, keep the mask on the border of the art-work surrounding the pine-apple silhouette and spray freehand in sepia to refine the shading and tone down the bright colours. Then remove all masking. Notice how the last two stages of spraying have modified the tone and colour of the greens and brought the shapes together.

SURFACE EFFECTS

Projects in this chapter give you some
new ideas to combine with the
techniques you have already learned,
to add depth and sparkle to the
surface detail of your paintings

HIGHLIGHTING

THE EFFECT OF USING AIRBRUSHED TONES AND COLOUR GRADATIONS TO CREATE SMOOTHLY MODELLED FORM AND SURFACE TEXTURE IS OFTEN ENHANCED BY THE APPLICATION OF BRILLIANT HIGHLIGHTING

A highlight is the brightest area on an object or surface, the part that reflects the most light. Highlights are pronounced on hard, shiny materials, such as glass or metal, but occur to some degree on most types of surface exposed to strong light from a directed source.

Clear highlights are essential for conveying the quality of a reflective surface, and help to emphasize modelling of shapes, especially on curves and angles turned towards the light. In airbrushing, you can achieve a powerful effect by grading from dark or mid-tones to light, fading them off to pure white. But there are additional ways of creating highlights that contribute sharpness to the image. They can be applied as finishing touches, so that you can work freely in early stages of your painting without having to take care to preserve clean white shapes.

The easiest method is to overpaint with opaque white, using gouache or acrylic. You can spray soft highlights with the airbrush, or paint hard shapes and linear highlighting with a fine sable or synthetic-hair paintbrush. The alternative is to make the highlights 'negatively'; for example, by scraping back the colour with a knife blade, or using a dampened cotton bud to lift transparent watercolour. The 'negative' techniques work best on a smooth, compact surface such as CS10 paper or illustration board.

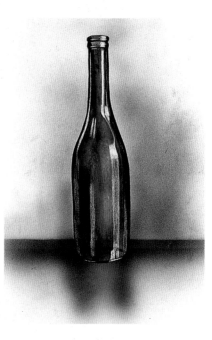

LINING WITH A BRUSH
The basic silhouette of these sunglasses was sprayed with black acrylic ink, using masking film to create hard-edged shapes. First the frames were coloured with solid black; on the lenses the tones were graded slightly. The lenses were then masked with tracing paper stencils and lightly sprayed with opaque white to make a soft sheen. The linear highlights on the frame were painted with a small brush. You can guide the brush along a tilted ruler when painting straight lines.

SCRATCHING BACK
The bottle was sprayed with black and green, in two stages using masking film. After the film was removed, the background tone was added before highlights were taken out by scratching into the colour with the blade of a sharp scalpel. Some highlights were left pure white, others resprayed with green.

STARBURSTS

The starburst is a classic effect of airbrushing, which is simple to achieve. Cut a fine cross or linear star shape in a piece of stiff paper or acetate, then hold the airbrush directly above the mask and spray a quick burst of white. You can add a soft halo of light at the centre of the cross after the mask is removed.

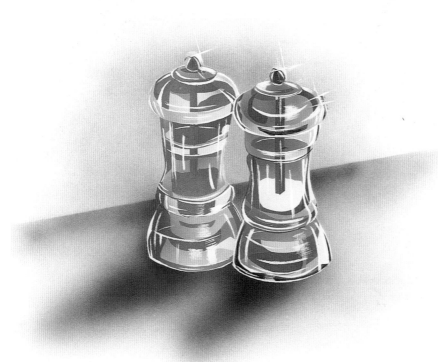

COMBINED TECHNIQUES

It is sometimes effective to use more than one highlighting technique in a piece of artwork. Here the pale tones were created by grading the colours while spraying through film masks. White highlights on the glass were scratched out with a scalpel and small opaque white starbursts were applied last to add sparkle.

LIGHT AND SHADOW

SHADOWS GIVE DEPTH AND IMPACT TO AN IMAGE, BUT FOR A
REALISTIC EFFECT, YOU NEED TO HAVE A CLEAR SENSE OF
HOW THEY RELATE CONSISTENTLY TO THE SOURCE OF LIGHT

In any image intended to convey space and form, however simple or complex, you have two major elements of light and shadow that influence the shapes and colours. One is the way light appears to model forms with graded tones and colours. This is the element that enables you to describe three-dimensionality in two-dimensional artwork.

Cast shadows – the shadow shapes that appear when an object blocks the light – can be dynamic visual features. They help to locate an object in its setting, and can also add mood and drama. Depending on the strength of the light, cast shadows may have soft graded tones or solid colour and hard edges.

To enhance contrasts, artists often assume a single light source, creating highlights on surfaces directly in the fall of light and shadows on areas turned away from the light. If you choose to apply this method, you must plot the relationships of light and shadow consistently. In reality, there may be more than one source creating more than one cast shadow from an object, or you may see reflected light coming from an unexpected direction. In the example of a ball resting on a flat surface, there is often a subtle halo of light on the shaded underside, reflecting from the ground plane. If you observe such effects very closely, you can use them to add realism to your work.

INDOOR LIGHT SOURCE
If your image includes objects with an orderly perspective construction, it is possible to work out the position of cast shadows by a similar system, locating the light source at the top of your paper and projecting down and across the image to find the shape and extent of shadows. This diagram shows a simple plot for a single interior light source.

OUTDOOR LIGHT SOURCE
This image shows a corresponding effect of cast shadow in an outdoor setting, assuming that the sun is the single source of directed light. Notice that the cast shadow always falls away from the shaded side of the object. To indicate the variable quality of natural light, the shadow tone is graded outward.

HEIGHT AND ANGLE

Cast shadows explain the position of an object in relation to the ground plane (top right), by the distance of the shadow from the object and its angle in relation to the light source. The intensity of tone also varies. In many situations, however, there is more than one light source, or light is reflected from different directions. Sometimes a double shadow (below right) gives a more realistic effect.

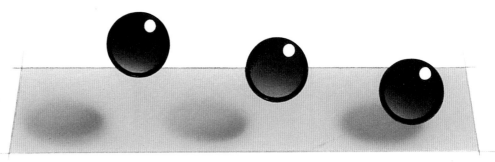

DROP SHADOW

This is a simple but effective technique for creating cast shadow from a hard-edged object. The same mask is used for the shadow as for the object; in this case, the circle of masking film through which the pool ball was sprayed was moved to the right and downward, then resprayed with light blue-grey. Notice that the highlight falls diagonally opposite the shadow area.

IRREGULAR SHAPES

Cast shadows in outdoor settings help to create mood and atmosphere. Here the heavy shadow of a tree trunk and its fragile branches fall across the panels of a door, which are modelled with linear shadows. The image was built up with film and paper masks, overlaying flat and spattered colour.

TEXTURE AND DEPTH

**MAKE USE OF THE VERSATILITY OF SIMPLE AIRBRUSHING
TECHNIQUES TO OBTAIN SURFACE VARIATIONS DESCRIBING
CHARACTERISTIC ELEMENTS OF YOUR SUBJECT**

Airbrushing is often associated with particular kinds of imagery but, as with any painting method, you can use the same basic techniques and key visual elements to convey a variety of physical effects. Highlights and shadows help to describe form, space, and surface texture. Airbrushed colour provides actual and illusionistic textural effects. Another feature that can create lively nuances in your paintings is reflected colour, the influence of one coloured material on an adjacent surface or object.

In the artwork shown opposite, the techniques and effects are employed to create specific contrasts. A section of a swimming pool and its tiled surround are isolated as a semi-abstract image. The exercise produces striking contrasts between the fluid and solid, translucent and opaque surfaces; technical details are analysed below. The painting was mainly executed using liquid watercolours, so most of the applied colour is transparent, although opaque white highlights were added.

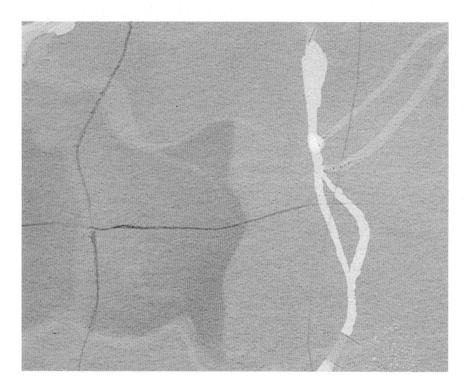

IRREGULAR HIGHLIGHTS
The pale highlights were painted out with masking fluid before any colour was applied. Oversprayed spots of brilliant white gouache knock back the tone. The pale blue traceries came from masking fluid lines brush-painted over the first layer of blue spraying. The wavy lines showing tiles on the base of the pool were drawn with blue pencil.

THREE-DIMENSIONAL FORM
The edges of the pool surround were created using cut cardboard masks to highlight the curves. Thick cardboard gives a soft but straight edge to the spray colour. The hard tones of the tiles were sprayed from light to dark with progressive film masking, then opaque white highlights were brush-painted along the tile edges. Spattered colour emphasizes the surface finish of the material.

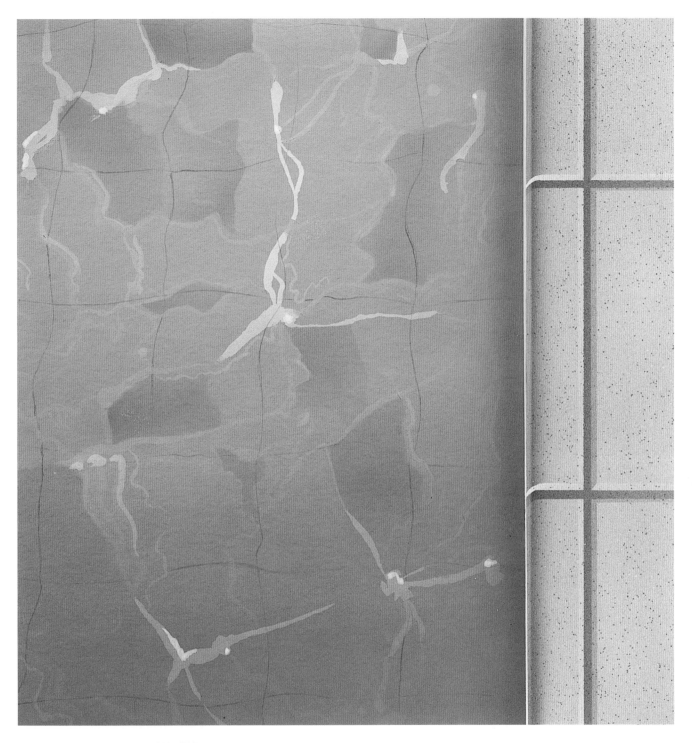

REFLECTED COLOUR
Green tints on the water surface suggest light and colour reflected from the pool surround.

POOLSIDE
The soft, flawless qualities of air-brushed colour are adapted to the texture of the hard geometric shapes and the irregular water patterns. Notice the hand-drawn and painted linear detail; many artists use pencil or brush drawing to sharpen fine details that are not so easily achieved with the airbrush.

TEXTURED AND COLOURED GROUNDS

**THE KIND OF PAPER YOU CHOOSE CAN CONTRIBUTE
PARTICULAR QUALITIES TO YOUR ARTWORK, EITHER
SUPPLYING A BASE COLOUR FOR THE SPRAYING OR A SPECIAL
TEXTURE THAT GIVES CHARACTER TO THE IMAGE**

Spraying on a white ground, whether paper, board or canvas usually gives you the most flexibility in developing your colour interpretation, especially when you are applying a transparent medium. But there are many beautiful textured and coloured papers available, and you may be tempted to try a different type of surface occasionally. It can provide a different way of tackling a familiar subject, or suggest a new kind of image.

Textured papers range from widely available heavy watercolour papers, which have a rough, pitted surface grain, to hand-made papers containing unusual fibres that create interestingly random elements of colour and texture. Some are quite fragile, and need careful planning of a suitable image and working method; others are more resilient and can stand up to adhesive masks and repeated spraying.

Coloured papers are mainly useful for supplying a dominant colour element in your subject, so that you do not have to spend time and trouble building up a base colour. Remember that the colour of the ground will always modify the applied colours of a transparent medium such as watercolour or ink, while gouache or acrylic paints rapidly build up opaque colour layers that obliterate the ground.

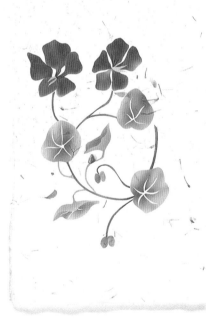

HAND-MADE PAPER
This paper is hand-made from cotton fibres mixed with fragments of marigold flowers and leaves. Although it has a delicate surface appearance, the paper is surprisingly tough. The image was sprayed through masking film.

PARCHMENT PAPER
The parchment effect provides an attractively marbled texture and soft natural colour, resembling a warm, stone-like finish which suggested the image of a low-relief decorative sculpture.

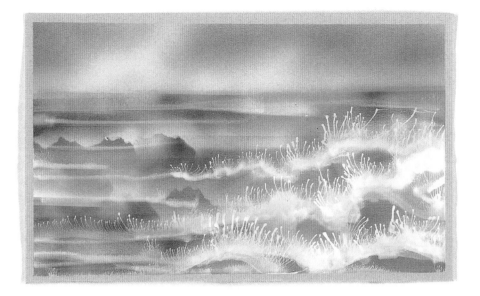

PASTEL PAPER

Ingres papers, sold in sheets or pads and often used for work in soft pastels, come in a range of subtle colours and have a pleasant, slightly toothed surface texture. This wave pattern was sprayed on blue-grey paper, using transparent inks to build up grey, green and blue shapes, then overspraying with opaque white to form the foaming wave crests.

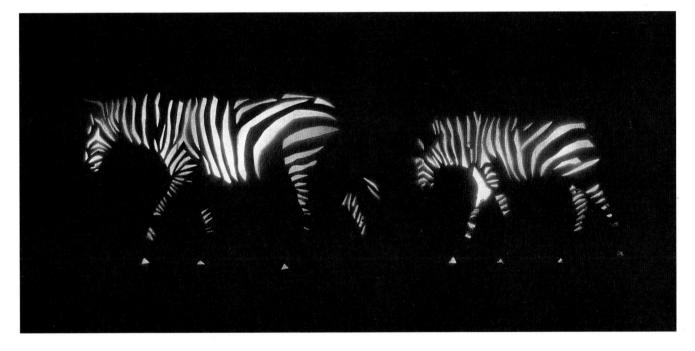

COLOURED PAPERS

Grounds in strong dark or bright primary colours produce a striking, graphic effect, as with the white-on-black zebra silhouettes (above). The white stripes were cut as stencils out of tracing paper strengthened with masking film. A coloured ground is useful when your subject has an obviously dominant colour, as in a green landscape (left). The blue and green gradations of sky and foliage were sprayed in gouache using torn-paper masks.

GRAPHIC
AND
3-D PROJECTS

Airbrushing is easily adapted to a wide
range of design and craft applications,
contributing its unique graphic and
decorative impact to two- and three-
dimensional projects

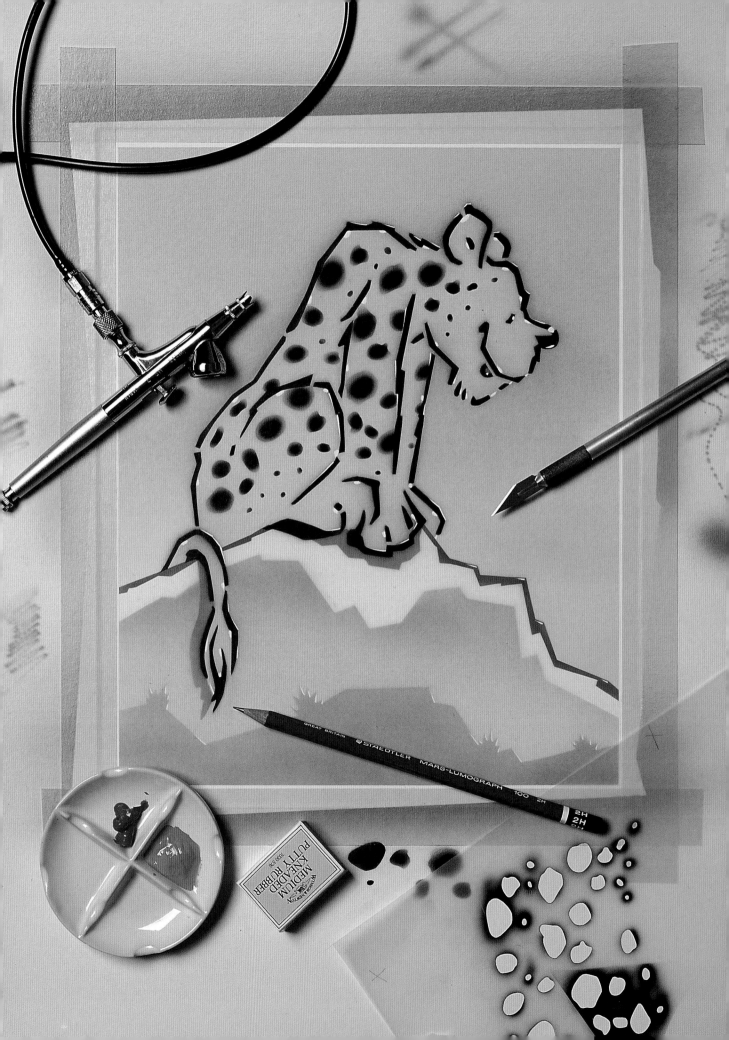

GRAPHIC STYLING

THE STYLISTIC FEATURES THAT GIVE A GRAPHIC EDGE TO
THIS PROJECT ARE THE CRISP OUTLINES, SMOOTHLY GRADED
COLOURS AND TOUCHES OF BRILLIANT HIGHLIGHTING

In complete contrast to the freehand animal drawings used as an initial airbrushing exercise (page 26), this leopard has been styled as a highly graphic, cartoon-like image. The key to this kind of interpretation is to simplify the naturalistic elements, creating a descriptive shape that conveys the type of animal and a sense of 'personality'.

For a one-off image, tracing paper stencils are adequate and quick to make. Having drawn up the outline, you can use it as a guide to making the colour stencil and the leopard-spot pattern. The advantage of using tracing paper here is that you can see through it, so you can centre the second and third stencils accurately on the outline image.

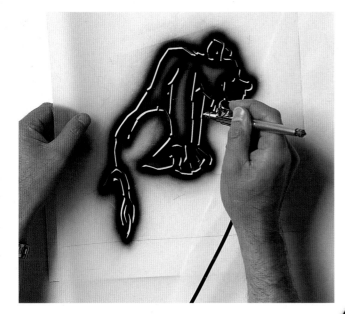

1 When drawing up the outline stencil, make a broken rather than continuous line, so the interior shape does not fall out when you cut it. Spray through the stencil with solid black.

EQUIPMENT

- Airbrush and air source
- Cartridge or watercolour paper
- Watercolours or acrylic inks
- Tracing paper
- Scalpel or craft knife
- White gouache
- Fine round-hair paintbrush

2 You may find that a little spray has blown under the tracing paper. This creates a softly shaded effect, which you can see here on the ears, legs and tail, but the shading does not detract from the strong outline.

3 Cut a stencil for the whole shape of the leopard, centre it on the outline and spray through with yellow-orange. You can apply the colour flatly, or create subtle modelling with graded tones.

4 Position the spot-pattern stencil and spray with solid black, as for the original outline. Again you may see some slight underspray around the shapes.

5 The brilliant highlights have been painted with a fine brush in opaque white. You can also give the leopard a simple, colourful setting using loose cut-paper masks to separate foreground and background, as shown on page 88.

STENCILLED LAMPSHADE

THIS PROJECT REFLECTS ONE OF THE EARLIEST COMMERCIAL
USES OF THE AIRBRUSH – AS A TOOL FOR DECORATING
FABRICS AND SOFT FURNISHINGS WITH STENCILLED
PATTERN MOTIFS

The process of airbrushing through stencils on to a three-dimensional object is the same in principle as stencilling on a flat surface. However, you need to calculate the shape of the stencil carefully to accommodate the curve of the lampshade.

Wrap a piece of tracing paper around the shade and mark off the top and bottom edges and the halfway line on either side. You can see the shape that the stencil should be in the picture below. Then measure in from the edges to locate the motifs at the centre of the stencil. As the motifs are repeated on each side of the shade, you need only make one stencil for each colour – draw separate outlines for the light blue, dark blue and green shapes.

Acrylic paint, thinned to milky consistency, is a suitable medium for this project. It becomes water-resistant when dry and artists' acrylic colours are lightfast.

EQUIPMENT

- Airbrush and air source
- Strong cartridge paper
- Acrylic paints
- Tracing paper
- Scalpel or craft knife
- Masking tape

1 Make the first stencil for the two large, light blue shapes only. Position them on the shade and spray evenly with ultramarine. Do not build up too much colour on this application. Repeat on the other side, making sure the motif is centred.

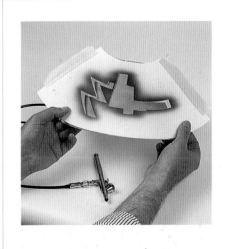

USING THE STENCIL

Make sure you measure the shape of the stencil accurately. It is not a semi-circle; the straight edges slope from top to bottom. When you wrap it around the shade, secure both sides with masking tape.

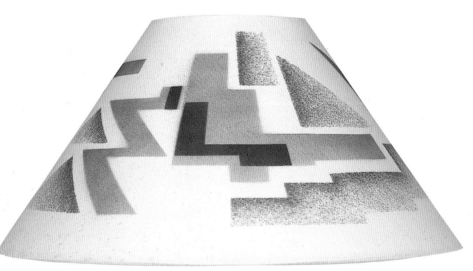

Work out the design on tracing paper, then transfer it to a heavy cartridge paper. Cartridge cuts with a clean, hard edge but is more flexible than cardboard for fitting tightly around the lampshade. Keep the stencils in position with masking tape at the edges.

2 Align the second stencil over the colour blocks. Spray again with ultramarine, building up the colour to a dark tone by over-spraying. Repeat on the other side and, when the colour has dried, position the smaller linking motifs at centre top and spray with cobalt blue.

3 Position the stencil for the green shapes. Spray the stippled texture by reducing the air pressure on your airbrush while releasing the full amount of medium. Spray from an angle across the left-hand and top edges of the cut-out shapes to obtain the shaded colour effect.

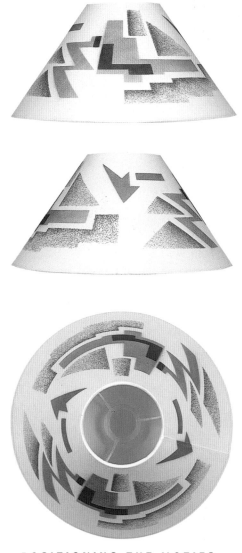

POSITIONING THE MOTIFS

The main motifs are repeated on opposite sides of the shade. A smaller, arrow-shaped motif fitted into the spaces in between them links up the pattern.

LIGHTING-UP TIME

With the warm glow of the lit lamp passing through the shade, the colour relationships and geometric emphasis of the design are subtly changed.

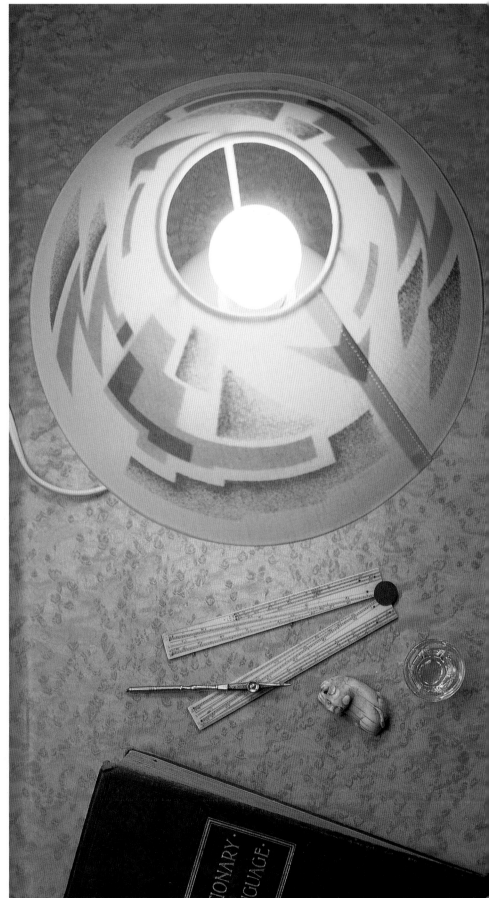

FABRIC PAINTING

THE MAIN ADVANTAGE OF USING THE AIRBRUSH ON FABRIC
IS THE DELICATE, SUBTLE VARIATIONS OF COLOUR AND
TEXTURE THAT YOU CAN ACHIEVE WITH THE FINE SPRAY

Painting on fabric is a popular craft and a wide range of specialist products has been developed for use on various types of materials. You can obtain general-purpose fabric paints usable on natural or synthetic fabrics, or colours particularly formulated for application to silk or synthetics. There are many attractive colours and the liquid consistency of the medium is usually directly suited to airbrushing technique, without the need for dilution of colours.

It is important to keep the material flat and fairly taut while you work, so that painted shapes do not become distorted. Fabric pieces can be taped or pinned down to the work surface. You can use paper, card or adhesive masks, or work freehand.

Follow the manufacturer's instructions for fixing the colour to make it washable. This is usually heat treatment, either pressing with an iron or putting the fabric in a tumble-drier.

EQUIPMENT
- Airbrush and air source
- Silk square
- Fabric paints
- Paper stencils
- Adhesive labels and/or dry-transfer symbols
- Masking film
- Scalpel
- Spray adhesive
- Mounting board
- Masking tape

PREPARATION
Assemble the materials you need before you start work. The motifs used as decoration in this project are both hand-drawn on paper and cut from adhesive labels. It is not essential to use silk as the fabric base, but for small-scale work such as a scarf it is easiest to use a relatively fine material with a tight, even weave and a smooth finish.

1 Draw the moon, shooting star and planet motifs on paper. Apply masking film to the paper before cutting; this strengthens the stencils and makes the surface waterproof. Cut out the motifs with a fine scalpel, varying the edge qualities so that some are smooth and regular, others free and rough-edged.

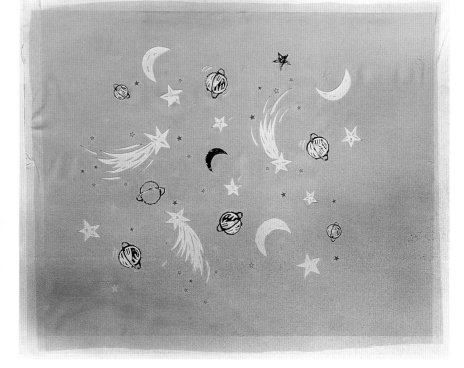

2 Lay the fabric flat on the mounting board and tape down all the edges, so the surface is stretched and smooth. Apply the motifs, using spray adhesive to fix the paper stencils in place. Use adhesive labels or dry-transfer motifs for the small stars and rub them down in position.

3 Apply all the required motifs at this stage. Keep the outer sections of the stencils as well as the shapes you have cut out.

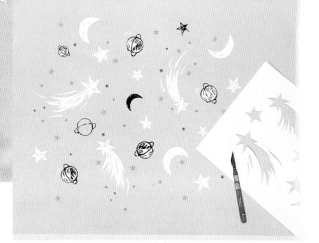

4 Spray your first colour right across the image area. In this sequence, blue is sprayed on to the grey silk. An even layer of fine spray is laid first, then the lower half of the square is resprayed to darken the colour. Finally, a coarser spatter effect is applied. Notice that the silk has begun to pucker slightly as the colour goes on; keep it smoothed out towards the edges, but wait until the colour has dried if you have to handle the fabric.

5 Overspray with a second colour; here it is red, producing violet tints where it overlays the blue. Remove some of the motifs and spray a third colour. You can replace some of the shapes slightly out of alignment, as in the shooting star (above), where the yellow spray overlaps the white shapes. You can also lift the stencils, cut out interior sections of the motifs and stick them down again before respraying. This produces a range of colour variations (right).

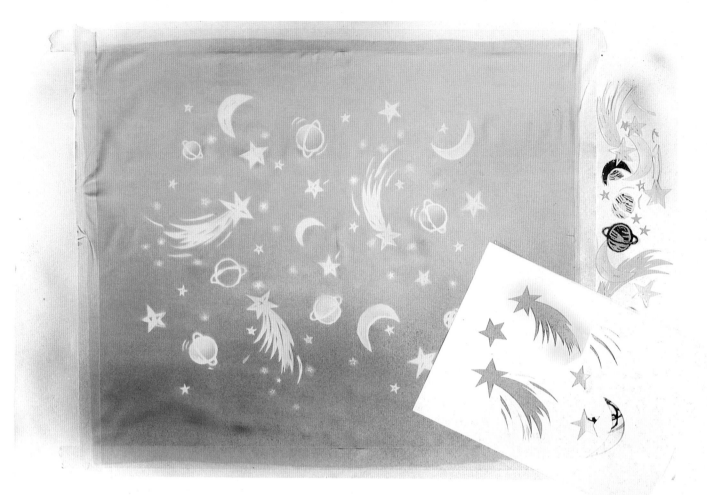

6 Take off all of the motifs and use the external stencil shapes to spray colour into some of the white areas. You can see here how this method has been used to colour some of the shooting stars, moons and planets. You can mix and vary the colours at any stage, but do not over-complicate the colour scheme. Keep the fabric flat by smoothing out the borders as necessary.

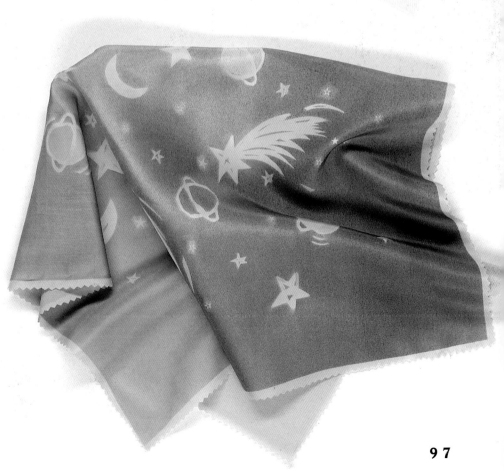

7 Make sure all the colour is dry, then remove the masking tape surround and lift the fabric from its backing board. Follow the paint manufacturer's instructions on 'fixing' the colour. You can finish the edges of the silk square neatly by cutting with pinking shears or stitching a fine hem.

CAFÉ POSTER

DRY-TRANSFER LETTERS ACT AS A FORM OF HARD MASKING.
THEIR CLEAN-EDGED, TYPOGRAPHIC PRECISION GIVES A
PROFESSIONAL FINISH TO LETTERING DESIGNS

To create a strong graphic impact, poster lettering needs to be bold and sharply defined, particularly if it is intended for multiple reproduction by printing or laser-copying. Hand-lettering is laborious and there is plenty of room for error both in constructing the letters and cutting masks for them, so dry-transfer letters save a lot of time and guarantee an effective result.

To use them as masking, you need to rub down the letters firmly so that the edges adhere and will not let airbrush spray pass underneath. However, as you later remove the lettering by picking it up on low-tack adhesive tape, it should not be rubbed so hard that you push it into the surface of your paper or board, or marks will be left behind.

A smooth surface is essential, so the letters go down cleanly and lift easily. A thin, pure white illustration board is ideal, although you can work on stiff, double-weight, smooth cartridge paper. Drawing papers with a fibrous or grainy surface are not suitable. As the colour work depends on building up layers of spray to develop darkening tones and mixed colours, use a transparent medium such as watercolour or ink.

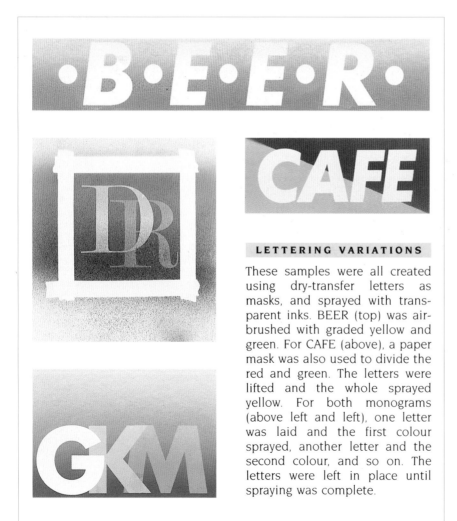

LETTERING VARIATIONS

These samples were all created using dry-transfer letters as masks, and sprayed with transparent inks. BEER (top) was airbrushed with graded yellow and green. For CAFE (above), a paper mask was also used to divide the red and green. The letters were lifted and the whole sprayed yellow. For both monograms (above left and left), one letter was laid and the first colour sprayed, another letter and the second colour, and so on. The letters were left in place until spraying was complete.

1 Make a careful layout of the design before starting work with the finished materials. Trace off the words letter by letter from the dry-transfer sheets, cut the tracings into strips and make a rough paste-up by taping them in position on a clean sheet. Then create a master tracing from the paste-up outlining the letters and the colour panels.

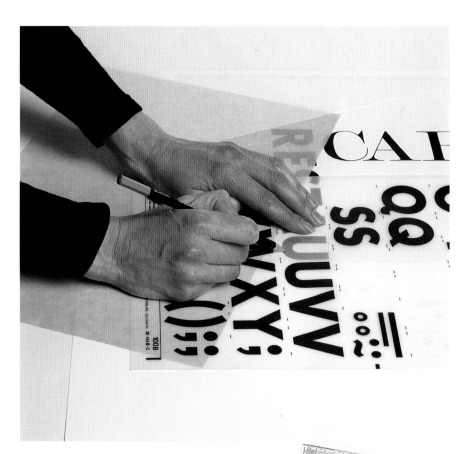

2 Rule very faint guidelines for the lettering on your illustration board – you need not trace down the letter outlines. Rub down the dry-transfer letters one by one. Make sure they are cleanly rubbed down but do not press too firmly, or it will be difficult to lift the lettering later.

4 The next step is to cover the whole image area with masking film, but you must first mask off the lettering with strips of tracing paper, or the film adhesive may damage the letters. Apply the film as shown on page 68, then cut out the rectangles around the lettering, leaving panels and borders masked. Spray the base of the design with blue, fading upward from the bottom.

EQUIPMENT
- Airbrush and air source
- Smooth illustration board
- Dry-transfer lettering
- Watercolours or acrylic inks
- Masking fluid
- Masking film
- Scalpel
- Tracing paper

3 Complete the two words, following the positioning and spacing on your master tracing. It is important in these early stages to keep the working surface clean. Keep drawing to a minimum and avoid making fingerprints on areas that you will be spraying with colour, as greasy marks can resist the airbrush spray. Lay loose sheets of tracing or layout paper over areas you are not working on, to protect the surface.

CAFE RESTAURANT

5 Turn the board around and spray with yellow from the top of the design, fading the colour down towards the blue at the centre.

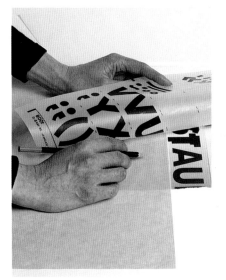

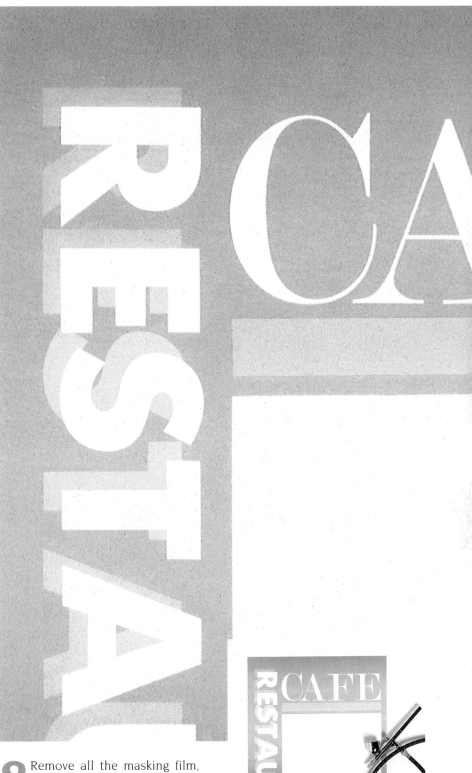

6 Make sure the colour is completely dry, then rub down the second layer of lettering on the word RESTAURANT, positioning the letters slightly below and off-centre from the first set. As the masking film now has colour on its surface, cover it with paper while you work, to avoid smearing.

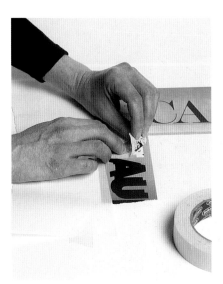

7 Remove masking from the top and bottom panels inside the lettered border. Spray the whole image again with blue across the bottom and yellow across the top. When the colour dries, use small sections of low-tack adhesive tape to pick up and peel back the dry-transfer letters.

8 Remove all the masking film, carefully avoiding smearing colour from the film on to the poster surface. The colour variations have been created simply by over-spraying, so the sections that have had only one layer of spray colour – the 'ghost' lettering and the inner panels – are lighter in tone than the background which is sprayed twice.

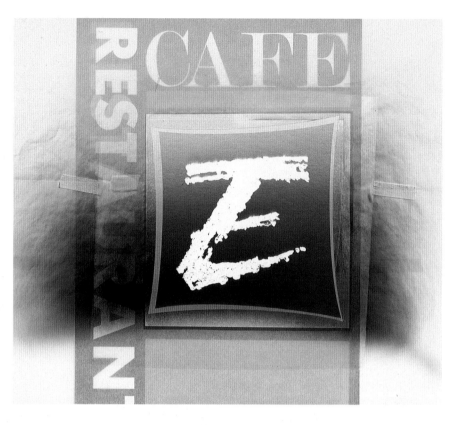

9 Cut a tracing paper 'frame' 1cm (½in) larger than the central panel and lay it over the sprayed border and lettering. Apply masking film to the central panel and cut the double lines that form the curving red frame within the square (see step 11). Lift the centre section of film from the panel and paint in the large letter **E**. using masking fluid thickly applied.

11 Lift the remaining slivers of masking film and spray the whole centre panel with red, grading the tone from light at the top to dark at the bottom. Let the colour dry, then rub off the masking fluid from the **E**.

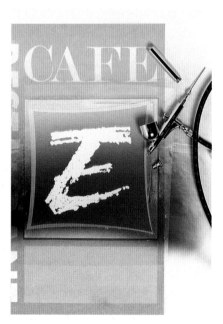

12 Spray the lower section of the **E** with yellow, then very lightly with red. The final step is to add a spatter effect over the centre panel. If you have a spatter cap for your airbrush, use it to create the coarse spray texture. If not, retract the airbrush needle and remove the nozzle cap, reposition the needle and spray by pulling the control button back for full flow of medium before introducing air.

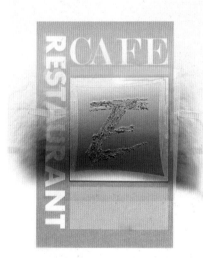

10 Spray the lower section of the central panel with blue, letting the colour fade upward toward the top. In this picture, you can clearly see the curving outlines of the panel surrounded by the masked borders. Remove the mask sections outside the curving border, taking care not to smudge the colour, and spray evenly with blue.

13 The finished poster has a clean, geometric effect enlivened by the hand-painted letter in the centre. The use of the double layer of lettering on the left gives depth to the image.

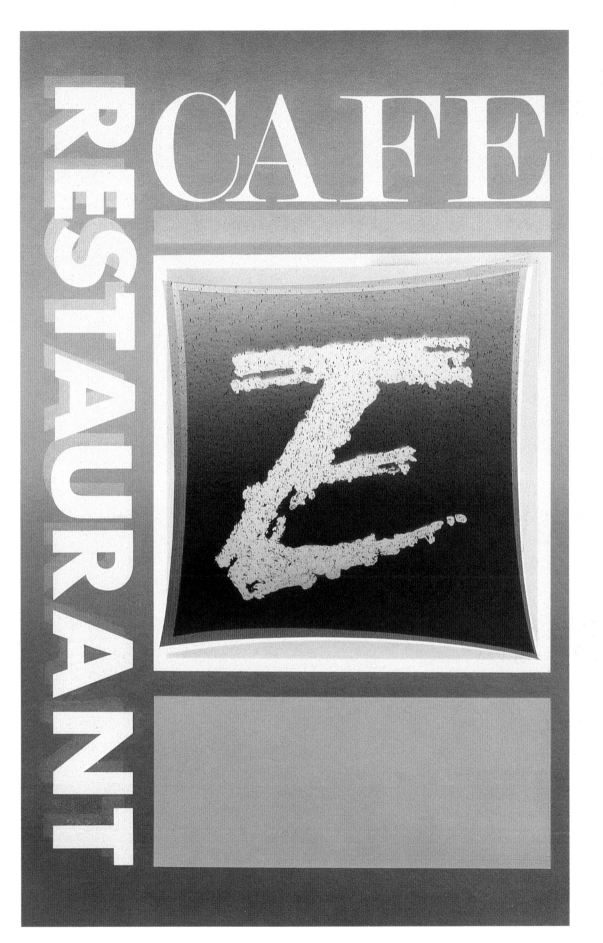

DECORATING PLASTICS AND CERAMICS

PLAIN, EVERYDAY HOUSEHOLD OBJECTS, SUCH AS PLASTIC
PLANT POTS OR CERAMIC DISHES, CAN BE TRANSFORMED
INTO UNIQUE DESIGN FEATURES WITH AN INVENTIVE
APPROACH TO AIRBRUSHED DECORATION

A completely plain, ordinary object such as a white plastic plant pot or glazed ceramic kitchen bowl is an ideal subject for airbrushed decoration. You can choose to apply a repeat pattern, an irregular textured effect, a simple stencil motif or a pre-planned picture. As both types of material have a smooth and resistant surface, you can work with loose or adhesive masks to create your design.

The plant pots illustrated here have been sprayed with a randomly marbled pattern, using applications of masking fluid (see pages 52-53) and several stages of overspraying to build up the complexity of the surface effect. The pudding dish shown opposite is decorated with more conventional stencilled motifs. In both designs, the characteristic soft colour gradations of the airbrush spray are employed to enhance the shapes and textures.

Plastics can be sprayed with ordinary acrylic paints, which once dry can be lightly wiped clean, but the colour will not stand up to repeated washing. There are specialized media for painting on plastics, ceramics and glass. Some are acrylic-based and can be diluted with water; and the airbrush can be flushed out with water. Others may have to be combined with their own thinners or solvent; follow the manufacturer's instructions. Remember such paints are not purpose-made for spraying, so ensure your workroom is well-ventilated, and use a face-mask to avoid inhaling the spray.

1 Wash the plastic pot with washing-up liquid or a household multi-surface cleaner to remove any grease. Dry the surface thoroughly and spray it lightly with red, to produce a pale pink coating. Overspray with light bursts of black, giving a delicate grey, then let the paint dry. Dribble masking fluid on to the rim of the pot at intervals and let it run down randomly. Allow the masking fluid to dry until it is clear and rubbery.

2 Respray the same two colours all over the surface of the pot as before. Do not build up the colour too heavily at this stage. When the paint is dry, peel away the trails of dried masking fluid. In some places, you may find it has removed all the colour underneath, revealing bands of white.

3 Drip the masking fluid on to the pot again, dry it off and then respray. When you remove the dried fluid this time, you will see a range of tones developing the random pattern effect.

CERAMIC DECORATION

The stencil motifs for decorating a plain pudding bowl were cut out of tracing paper strengthened with masking film. This provides a flexible, see-through mask so you can wrap it around the curved surface and also register one colour accurately on another. The stencil was cut and sprayed in two stages: first the brown stalks and shading; then the green leaves and apples. Then the rim of the bowl was covered with masking tape and the ribbon-like pattern was also cut and sprayed in two colour stages.

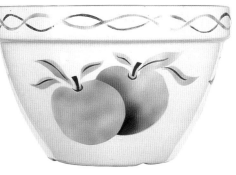

When you are painting something used as a food container, you are advised not to colour surfaces that will come in direct contact with the food. Check the

manufacturer's instructions on whether the ceramic paint is washable. This decoration was 'fixed' by heating in an ordinary domestic oven on low heat.

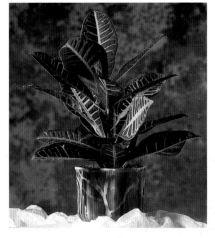

DECORATIVE SETS
If you have a collection of similar pots, this technique gives each one a unique decoration, but they have enough similarity in the colour and texture to form a co-ordinated set.

4 Continue the masking and spraying processes until you achieve a satisfactory design, building up the colour strength as required. Part of the interest of this technique is that you cannot fully control the visual effects, and the end result (right) is somewhat unpredictable.

EQUIPMENT
- Airbrush and air source
- White plastic plant pots
- Masking fluid
- Acrylic-based colours

COLOURING A MODEL

**AIRBRUSHING IS A QUICK AND EASY WAY TO COVER A THREE-
DIMENSIONAL FORM WITH COLOUR, WHETHER YOU WANT
A SMOOTHLY SPRAYED FINISH OR AN ATTRACTIVE
SURFACE TEXTURE**

One of the most popular and versatile applications of airbrushing is in model-making, where the airbrush is used to colour everything from plastic model kits to architectural models to latex-cast characters for animated films. But there is a special satisfaction to spraying a model that you have constructed fully from start to finish, the end result being a unique piece of coloured sculpture.

Without any special facilities, you can easily make a model from cardboard, papier maché or plaster. The character of the material should be suited to the subject and style of the work. Cardboard is obviously a good choice for architectural models or regular geometric forms, while papier maché and plaster provide a more organic feel. Papier maché is made with strips or scraps of newspaper soaked in a glue size such as wallpaper paste. Plaster of Paris is readily available from art and craft retail outlets. You can paint these materials with acrylic paints, once they are fully dry.

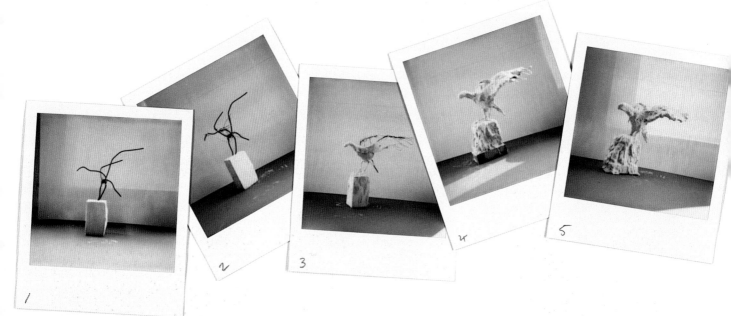

EQUIPMENT

- Airbrush and air source
- Acrylic paints
- Wire
- Wire cutters
- Newspaper or fine gauze strips
- Plaster of Paris
- Mixing bowl for plaster

**CONSTRUCTING
A PLASTER MODEL**

If you are making a free-standing, fully rounded model in plaster, you need to begin with an armature, a skeleton structure that provides balance and strength as the plaster is applied. You can make this from two or three grades of thick wire, using a heavy-gauge wire for the main linear elements of the shape and a lighter, more pliable wire to model detailed parts.

You can then construct the basic form over the armature using strips of newspaper or gauze soaked in plaster. As the modelling builds up, you can apply the thickening plaster directly. Allow plenty of drying time before you start to apply colour; although plaster sets very quickly, the finished model takes days to dry out fully. When it is dry, you can carve it with a penknife or file down the surface to refine the detail and finish.

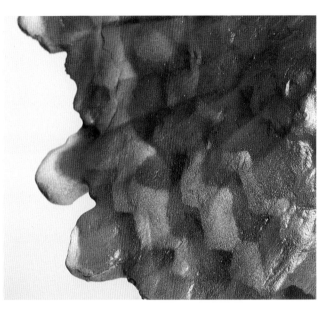

PAPER MASKS
Bands of black and white were sprayed on the wings over torn paper masks. A light spray of burnt sienna was laid over them to knock back the contrast.

APPLYING COLOUR
The style of the model is a rough-cast, impressionistic interpretation, so the colour is broadly textural rather than naturalistic. The model was first sprayed all over with graded tones of orange, burnt sienna and black acrylic, then the textures were added as described in the detail pictures. A final glaze of acrylic medium was applied to seal the colour and add surface gloss.

BRUSH PAINTING
The finer texture on the head and body of the bird was painted with a fine sable brush in light orange, then overlaid with burnt sienna spray.

COLOUR CONTRAST
To create pure white highlights on the underside of the head and body, white acrylic was painted thickly with a brush.

FREE TEXTURE
The rock was sprayed with black and grey acrylic, then a thin glaze of white was poured over raised areas to pick up surface variations.

CORRECTION AND RETOUCHING

The airbrush is often used as a
technical tool, particularly in photo-
retouching and handtinting, which are
demonstrated here using simple
techniques and familiar materials

CORRECTING WITH A PATCH

IF YOU MAKE AN ERROR THAT CANNOT BE SPRAYED OUT
EASILY ON A DETAILED PIECE OF ARTWORK, IT IS POSSIBLE
TO PATCH IN A NEW PIECE OF PAPER QUITE ACCURATELY

This method of correction is ideal for an image in which there are definite key-lines that you can work to. In a loosely worked or atmospheric picture, the edges of an inset patch may show even after respraying. But in a graphic image like this pineapple, you can use the darkest lines within the picture to frame the section you cut out. The naturally hard-edged shapes will disguise the patching.

The basic principle of this technique is to cut out the spoilt area of the artwork at the same time as cutting through a clean piece of paper underneath. You then have a perfect replica of the shape you have removed, which can just be inserted in to the artwork and secured. It is surprisingly easy and effective, as long as you use the same type of paper as for the original and cut cleanly in one piece.

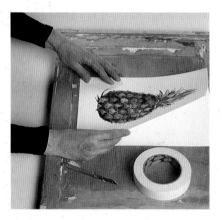

1 For the patch, use the same quality and thickness of paper as you used for the original artwork. Lay down the clean sheet on a drawing board and position the artwork over it. Tape the corners to keep both sheets in place.

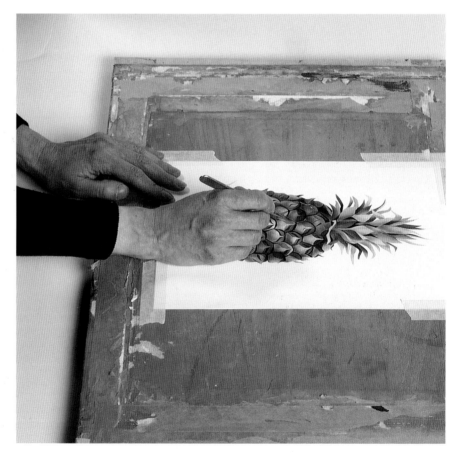

2 With a fine, sharp knife, cut around the area of the picture where you made the error. Press firmly so that the knife blade cuts cleanly through both sheets of paper.

3 Remove the cut section from the artwork. Pick up the clean paper patch from underneath and check that it fits exactly.

4 Fit the new patch carefully to the artwork and secure it on the back of the paper with pieces of masking tape.

5 With the clean patch in place, you can now trace in that section of your drawing and rework it by applying a new mask and following the stages of your original spraying process.

HANDTINTING PHOTOGRAPHS

IF YOU HAVE A STRONG PHOTOGRAPHIC IMAGE IN BLACK AND WHITE, SIMPLE TECHNIQUES OF COLOUR SPRAYING WITH TRANSPARENT INKS OR WATERCOLOURS CAN HAVE A SPECTACULAR EFFECT

Colour adds atmosphere and individuality to a photographic print. The monochrome framework of the photograph holds the colour areas together, even when the spraying is done freehand and very loosely applied to the shapes. Sometimes it is effective to complement the black and white by using only one or two tinting colours. At other times, you may want to do a detailed and naturalistic colour rendering.

If it is necessary to create masking for detailed shapes within the image, there are several ways to do it. You can cut individual paper stencils for particular shapes, by tracing them off. You can take photocopies of the photograph and cut out different parts to make separate masks for each colour. Or you can use adhesive masking film, which enables you to see exactly what you need to cut by working from the original underneath; however, it can be tricky to cut the film without scoring the surface layer of the photograph.

Watercolours are ideal for handtinting because they are transparent, so the black image remains powerfully graphic. Acrylic inks have a transparent effect if used lightly, or can be made more opaque by building up the sprayed layers. If you want to make a more complex interpretation of the picture that adds to or enhances the existing detail, you may need to use a fully opaque medium like gouache.

1 Start with the lightest colour you intend to use – in this case yellow, and spray lightly and freely into the appropriate areas of the photograph.

2 Continue with the mid-tones, gradually extending the colour areas. Move close to the surface when you need to confine the spray, as with the bands of blue in the water reflection.

MASKING INDIVIDUAL SHAPES

Photocopies make ideal masks for isolating specific shapes within the image. Take several copies of your original photograph and cut out the relevant sections to form separate stencil masks for each colour.

3 With transparent watercolour, you can layer one colour over another to obtain subtler mixed hues. The palette used here consists of yellow, blue, bright green, deep green and warm brown.

PHOTOMONTAGE

AIRBRUSHING TECHNIQUES HAVE A LONG-ESTABLISHED
ASSOCIATION WITH PHOTOGRAPHY, PROVIDING SUBTLE WAYS
OF VARYING DETAIL AND INTEGRATING MULTIPLE IMAGES

Before the advent of computer programs with sophisticated methods of altering photographic images, airbrushing was one of the primary techniques for photo-retouching. The delicate, flawless qualities of airbrushed colour enable it to be graded imperceptibly into photographic tones. Airbrushing can be used to brush out unwanted details of a picture or insert new colours and shapes, and to overlay joins in a montage of different images.

A montage is simply an assembly of various images stuck down on a background surface. It is an interesting way of combining different photographic elements, or of integrating hand-drawn or painted images with photographs. The composition can be more or less random or have a deliberate theme, like the montage shown here, which alludes to the history of photography. Several basic airbrushing and masking techniques are applied in this project.

EQUIPMENT

- Airbrush and air source
- Watercolour and gouache paints
- Photographic materials (prints, negatives, magazine tear-sheets)
- Dry-transfer lettering
- Backing board for montage
- Paper and cardboard for masking
- Masking tape
- Scissors
- Scalpel
- General-purpose adhesive
- White spirit
- Large spoon

PREPARING YOUR MATERIAL
When you have assembled some pictures that you wish to use in your montage, you will find it helpful to sketch out a pencil rough for the composition, so that you can plan how to put the images together and check whether you need additional material. Use the drawing as a guideline for starting work, but allow the montage to develop its own character as you progress.

1 The background image is a photographic transfer taken from a magazine print. Dampen the picture with white spirit, lay it face down on the backing board and rub the back of the paper with a spoon to transfer the colour.

2 To apply surrounding colour, use torn-paper masks to create rough-edged shapes. The artist has also previously applied dry-transfer numerals as masks.

3 Gradually build up the image by combining different techniques, such as freehand spraying and masking with tape, as shown here. At this stage, the composition still looks disjointed, but as more features are added they will gradually cohere. Cut out the pictures you intend to add and lay them on the backing board to check their scale and position in the overall design.

4 Decide how the pictures should fit or overlap, then stick them down on the backing board. Depending on the adhesive you use, you may need to allow time for it to dry before you continue spraying. Work over the top of the montage with watercolour or gouache, to obtain areas of transparent or opaque colour. In this example, tracing paper and cardboard masks have been used to produce hard-edged, rough and veiled shapes.

5 In keeping with the theme of the montage, the artist uses a length of photographic film negative as a mask, and sprays through the socket holes to create a recognizable repeat pattern.

6 In the finished montage, the combination of airbrushed textures and colours helps to unify the pictures. The selected masking techniques have also extended the variety of visual elements in the design, giving the composition plenty of active surface detail.

Making the montage Sections were taken from two photographs to make the basic image. One was of a person's hands in the gloves, holding the cards; the other of the empty gloves with the wristbands propped open, shot at the same angle. The external and internal shapes of the gloves were cut out and pasted on a black background.

COLOUR RETOUCHING

Airbrushing has a history of being employed to assist photographic illusions, from sharpening up product shots for advertising to making figures 'disappear' mysteriously from group photographs. This example of colour retouching comes from work on a book cover with an illusionist theme (above). The disembodied hands holding the cards are contrived from separate images pasted together on a background and retouched with airbrushed colour to disguise imperfections in the montage.

You can use this method to combine or alter your own monochrome or colour prints. You need to make sure that different elements of the subject are in scale with each other. When you have assembled the montage, you can spray it directly with opaque paint or, as in this example, have a clean print made of the composite image so that the physical joins no longer appear in your final version.

Reprinting To obtain a clean image, the montage was photographed and a new print was made. But the insides of the gloves do not quite fit into the outer parts, leaving a narrow black band between them, and the wire props inside are visible.

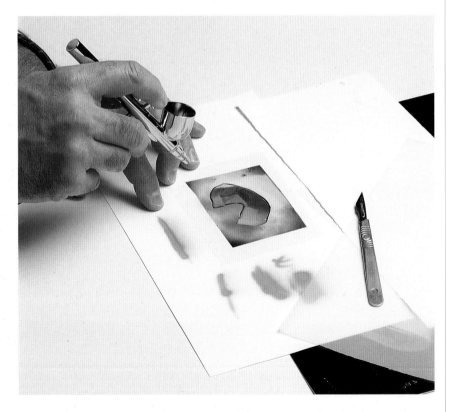

Airbrushing the print The gloves were masked with film and the inner shapes and outer edges were sprayed with white and grey to provide appropriate shading and a smooth finish.

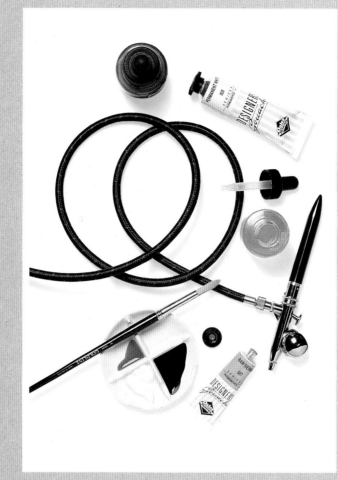

7

PRACTICAL REFERENCE

This quick-access reference section
gives practical advice on suitable
media and surfaces for your projects,
safe working practice, and what to do
when things go wrong

MEDIA AND SURFACES

YOU CAN THEORETICALLY AIRBRUSH MOST MEDIA ON TO
MOST SURFACES, BUT THE GUIDELINES BELOW WILL HELP
YOU TO CHOOSE APPROPRIATE AND COMPATIBLE
MATERIALS FOR YOUR RANGE OF WORK

PAINT CONSISTENCY

As a general rule, the consistency of paint for spraying should be similar to that of milk. Make sure the colour is of a suitable intensity, not too watery, and that the medium flows freely without lumps or gritty particles that could clog the airbrush internally. Load the diluted medium into the airbrush colour cup using a sable or synthetic, medium or large round-hair paintbrush.

Liquid watercolours and coloured drawing inks are ready for use as they are. They can be mixed to make new colours, but need no dilution. If you are using an oil- or spirit-based medium for special purposes, check the manufacturer's instructions on appropriate thinners and solvents for dilution and cleansing.

Many colour ranges now include metallic colours. These are not recommended for airbrushing as they contain metallic particles that can damage internal airbrush mechanisms.

SURFACES

It is possible to apply airbrushed colour to any of the wide range of drawing and watercolour papers available from artists' suppliers and stationers. Thin papers such as newsprint or layout paper buckle when heavily dampened by the spray, but they are adequate for airbrushing practice when you want a plentiful and cheap supply of paper.

For finished works, choose heavy cartridge paper or papers sold for pastel or watercolour painting. Cartridge has a smooth finish and is available in single and double weights, usually in pure white or cream, but there are also some attractive bright colours suitable for certain types of image (see also pages 84-85). Pastel papers are slightly more grainy, but this does not affect the quality of the airbrush spray noticeably. These are sold in sheets or pads, in white and a range of subtle colours.

Watercolour papers are available in a variety of weights and finishes. The main categories of finish are hot-pressed (smooth); 'not' or cold-pressed (medium-grainy surface); and rough (heavily toothed grain). Airbrush spray falls evenly on a smooth surface, but itself appears more grainy if the paper surface is rough. This can produce a pleasing finish to a painting, but it can be difficult to obtain fine detail and completely hard edges. The type of paper that you choose should be related to the style of your image.

If your paper is likely to be thoroughly wetted during the colour work, first stretch it on a drawing board by soaking the whole sheet in water and taping down the paper edges with gummed paper tape. Let it dry out completely before you start spraying. Heavyweight papers can be taped down with masking tape all around the edges, as buckling is minimal.

Papers and boards for illustration work vary from extremely compact, smooth surfaces such as CS10 or line board to watercolour papers mounted on board, giving a textured finish on a rigid backing. You can also use ordinary cardboard or packing boards for rougher effects. Mount boards have a layered composition; they can be suitable for spraying but the top layer may lift if it becomes soaked with colour. Clear acetate can also be used as a spraying surface, and it is particularly suitable if you want luminous colour effects, layered overlays, or fully transparent images that can be projected.

WATERCOLOUR

Artists' quality watercolours are available in tubes or pans, in a wide range of colours. Most are reliably lightfast; the label shows a rating for degree of permanency.

Tube colours are easier to use than pans; brush them out with water in a ceramic or plastic well palette. Flush out the airbrush with clean water after spraying.

Liquid watercolours are easy to use and an excellent medium for airbrushing. The only drawback is that the colours are not always guaranteed permanent as are most artists' tube colours.

Surfaces Drawing and watercolour papers, illustration boards, cardboard. Watercolours are translucent, so a pure white surface is best; a coloured ground will modify the sprayed colours.

GOUACHE

This is a popular medium for airbrushing because the colours are strong but opaque, so you can build up layers quickly, make changes or cover errors. It is water-based; water is used as the paint diluent and for cleaning the airbrush.

Some colours are grainy because the pigment particles are comparatively large, and wet colour mixes sometimes separate in the palette; stir the fluid paint with a brush immediately before loading into the colour cup.

Gouache is available in a wide range of colours but not all are fully permanent, so check the manufacturer's ratings for lightfastness.
Surfaces Drawing and watercolour papers, pastel papers, illustration boards, cardboard.

DRAWING INKS
There are various brands of coloured drawing inks, all of which can be used without dilution for airbrushing. Many are sold in bottles with integral droppers fixed to the lids, which makes it easy to load colour into the airbrush cup

Take special care if you use inks described as waterproof. If you allow waterproof colour to dry within the airbrush nozzle it can be very difficult to remove and possibly damaging to internal mechanisms. Rinse out the tool with water even if you are only stopping work for a brief period, and be sure to flush out very thoroughly when you finish spraying.
Surfaces Drawing and watercolour papers, illustration boards, cardboard, acetate.

ACRYLICS
Acrylic paints are diluted and cleansed with water, but become waterproof when dry. Acrylic builds up a resilient surface and you can make corrections to your artwork by overlaying colours. Artists' acrylic paints are available in tubes and jars, in a wide range of colours, and are fully permanent.

The paint is viscous and has to be brushed out with water to spraying consistency. 'Flow' acrylics dilute more smoothly than thicker tube paints, but you can pass the liquid through a fine strainer to eliminate any lumps that may clog the airbrush paint channel or nozzle. If you mix large quantities of frequently used colours, they can be stored in glass jars. Liquid gloss and matt acrylic mediums are available that can be mixed with the paint or sprayed on as a varnishing layer.

Acrylic inks combine the resilience of the paints with the fluidity and translucency of ink. They are excellent for airbrushing but colours may lack the permanency of artists' paints; check the manufacturer's advice on lightfastness.
Surfaces Drawing and watercolour papers, illustration boards, cardboard, acetate; (for paint) canvas, canvas boards, wood and composition boards. Diluted with colour will soak into canvas and 'sink', requiring several layers to build colour strength. You can seal the surface of canvas or wood with a white acrylic primer before spraying. Acrylics can also be used on papier maché, plaster and some plastics.

OIL PAINT
This medium is far from ideal for airbrush work. As it is very slow-drying, it is not easy to layer the colours effectively or to mask out shapes. It is also messy, as the paint has to be diluted with turpentine and the airbrush fully flushed out with turpentine or white spirit to remove all the oily colour. If used persistently, the solvent may damage internal parts of the airbrush.

However, airbrushing can be effective as an occasional supplement to brush-painting with oils, for fine colour glazes or atmospheric effects. It is essential always to use a face-mask when spraying oil-based media.
Surfaces Canvas, canvas board, wood panel, composition board. Surfaces for oil painting must be sealed and primed beforehand.

FABRIC PAINTS
Specialized fabric paints are available from art and craft suppliers. There is a smaller colour range than in artists' paints, but colours can be mixed and overlaid. Choose a type suitable for the fabric you have chosen. Follow the manufacturer's instructions for preparation and fixing of the colour.

Surfaces Fabric pieces, T-shirts and similar natural- or synthetic-fibre garments, scarves, cloth bags and similar fashion accessories.

OTHER MEDIA
Various liquid colour ranges are available for work on glass, ceramics, metals and plastics. Follow the manufacturer's instructions for preparation, application and fixing. Some types are acrylic-based and miscible with water, but for others special thinners and solvents may be required.

Observe safety rules on working in a well-ventilated space and wearing a face-mask when using unfamiliar media, especially those not purpose-made for airbrushing.
Surfaces Materials as advised by manufacturer's instructions.

COLOUR PERMANENCE

Paint ranges include colours of variable permanence; most are lightfast, but a few are naturally fugitive. In general, paints called artists' colours are high quality and fully permanent, whereas some inks and liquid colours are formulated for work intended for reproduction and may be less reliable; check the manufacturer's rating. Do not display finished artwork in direct sunlight, which can cause colours to fade rapidly.

CLEANING AND MAINTENANCE

YOUR AIRBRUSHING EQUIPMENT IS A LONG-TERM
INVESTMENT, SO FOLLOW ROUTINE, COMMONSENSE
PROCEDURES TO MAINTAIN IT IN THE BEST CONDITION,
AND PAY ATTENTION TO SAFE WORKING PRACTICES

REGULAR CLEANING

To ensure that the internal cavities of the airbrush do not become clogged with colour, flush out thoroughly every time you stop work, even if only for a short period. With all water-based media, load the airbrush colour cup with clean water and run it through, repeating until the spray becomes clear and colour-free. You can alternatively use a proprietary brand airbrush cleaning fluid. Then pass air through the airbrush to dry out the paint channel and nozzle.

If you are using a medium that requires a special solvent, run the solvent through until colour traces are gone, then flush out with water. You need to clean out the solvent as well as the colour, as some types can corrode non-metal internal parts of the airbrush.

CLEARING BLOCKAGES

If you notice interruption to the regularity of the airbrush spray that suggests you have a build-up of colour blocking the paint channel or nozzle, there are two methods that may help you to clear it. First, try passing an airbrush cleaning fluid through the tool at the highest allowable pressure.

If this does not work, remove the airbrush nozzle, and colour cup if it is detachable, and allow the parts to soak for a brief period in cleaning fluid. Reassemble the airbrush and spray out residual cleaning fluid from the cup and nozzle. You can then rinse it through with water once the blockage has cleared.

If you can see dried paint on the nozzle, be careful how you remove it. After soaking, try brushing with a soft paintbrush. Avoid using a blade or needle to scrape out the nozzle, as this can damage the delicate internal components.

INTERNAL CLEANING

With many airbrush models, it is possible to dismantle the airbrush body and remove the central needle that channels the paint. You can then wipe off any paint residue clinging to the needle, that may otherwise dry inside the airbrush or pass into and block the nozzle. You must handle the needle carefully, however; if you drop it, bend it or blunt the point, the spray quality of your airbrush will be affected. Follow the manufacturer's instructions on disassembly, but avoid disconnecting and handling internal parts more than is absolutely essential. Be especially careful with the smaller fitments of the nozzle and needle.

CLEANING CHECKLIST

• If you are using a heavy medium such as gouache or one that dries to a waterproof finish, such as acrylic or waterproof ink, flush out with clean water between colour changes to ensure no lumps or paint particles stay in the nozzle.

• Flush out the airbrush thoroughly every time you stop work. Pass air through after cleaning to dry out the internal parts.

• Never put the whole airbrush in water or cleaning fluid to soak. If you need to soak the nozzle or a detachable colour cup, return them to the airbrush as quickly as possible and follow the regular routine for flushing out.

• During flushing out, a large quantity of paint and water particles is released. To avoid a build-up of moisture in the air, spray off into paper towels, a plastic container or a purpose-made cleaning station.

• In some airbrush models, you can take the nozzle apart for cleaning. Soak only metal parts of the nozzle, not the rubber washer.

• If you disassemble part or all of your airbrush, note carefully the sequence by which parts are detached. Keep them together in a tray to avoid losing components.

REPAIRS

Good-quality airbrushes are precision instruments constructed to delicate specifications. There are certainly limits to what you can or should do to attempt repairs. If you have a problem you cannot solve, get in touch with the manufacturer, the retailer who sold you the airbrush, or a servicing agency. Staff at local retail outlets are not necessarily qualified to undertake repairs and servicing themselves, but should be able to put you in touch with a specialist airbrush agent.

Various spare parts are sold for particular airbrush models. The items which you can most easily replace yourself are the nozzle or the needle. Get advice from the supplier to ensure that you obtain the correct type and size of replacement part for your own airbrush model.

COMPRESSOR MAINTENANCE

Compressors are not designed to endure inexpert tinkering. Never attempt to dismantle or open up the compressor body. If you feel you have a problem originating with the compressor rather than with the airbrush, get specialist advice from the manufacturer or servicing agent.

Otherwise, simply treat the compressor with the respect it deserves. Let it stand squarely upright on a supportive, level surface. If it runs on oil, keep an eye on the oil level and top up according to the manufacturer's instructions. When spraying, keep strictly to the pressure levels recommended for your type of airbrush and medium.

General maintenance procedure includes draining the filter system that extracts moisture from the air supply to prevent irregularities in the spray consistency. This is typically a narrow glass bowl sited near the pressure gauge, which can be unscrewed and emptied. Perhaps once a year, you may also need to replace the interior filter.

The oil in a storage compressor needs changing regularly, though not necessarily often. The oil-change should be an annual procedure; or every six months if you are using your airbrush constantly.

Air hoses are durable and resilient. If you suspect an air leak, check whether it is in the hose or connector, and replace the damaged part. Before you start work, make sure the hose is not twisted or trapped in any way that may prevent free passage of air.

SAFE WORKING PRACTICE

- Before you start work with your airbrush, read the manufacturer's instructions carefully with special regard to procedures for attaching the airbrush to the air source and setting the pressure.

- Check manufacturer's instructions on the correct air pressure for the airbrush model and medium that you are using. There is no advantage to setting a higher pressure than is recommended, and it can cause damage to the internal mechanisms of the airbrush.

- Never direct the spray jet at any part of your own body; keep it well away from your face and eyes while the airbrush is active. Test pressure and spray quality by spraying on to spare paper.

- Set up your work area in a reasonably large, well-ventilated space. If you do airbrush work regularly, it is advisable to fit an extractor fan in your studio. More practical domestically are small electrically powered 'desktop' extractors, which take in the surrounding air, pass it through a filter and release it purified. Otherwise, work in a large room with door and window open to allow air circulation.

- Residual spray passes well beyond your work surface and because it is so fine, you cannot see the build up of sprayed medium in the air. It is recommended that you wear a face mask while airbrushing, as you are otherwise constantly breathing in contaminated air. This is essential when you are spraying oil-, spirit- or cellulose-based media, but even some of the pigments that form the colour ingredients of paints are relatively toxic, so play it safe.

- Do not spray colour or flush out the airbrush within close range of electrical sockets or connectors. Position electrical studio equipment, such as a lamp, fan or dryer, out of range of your immediate work area.

TROUBLESHOOTING

THIS CHART IS A GUIDE TO THE COMMON PROBLEMS THAT
OCCUR IN AIRBRUSHING AND WILL HELP YOU TO DECIDE
WHETHER YOUR PROBLEM IS DUE TO OPERATOR ERROR, A
TEMPORARY BLOCKAGE IN THE SYSTEM, OR MECHANICAL FAULTS

PROBLEM	POSSIBLE CAUSE	ACTION/REMEDY
Uneven, spattered or coarse spray	Air pressure too low	Adjust pressure gauge
	Damage to or blockage in nozzle	Check and clean nozzle; replace if necessary
	Medium too heavy	Empty colour cup and flush out. Re-mix medium to more dilute consistency
	Needle damaged or incorrectly aligned	Check and re-set needle; replace if necessary
Medium floods working surfaces	Medium too dilute	Empty colour cup and re-mix medium to suitable consistency
	Incorrect ratio of medium to air	Adjust your control button operation; check air pressure required for medium
	Overspraying too heavy	Allow drying time between paint layers
Colour forms blots or spidery trails	Airbrush too close to surface	Pull back from surface
	Incorrect operation of control button for correct air/paint ratio	Practise control before returning to spraying on artwork
Flaring or spitting at start or end of airbrush pass	Incorrect operation of control button or irregular airbrushing action	Practise control before returning to spraying on artwork
Angled or diffused spray pattern	Damage to nozzle or needle	Check and re-set nozzle and needle; replace part if necessary

NOTE: If none of these simpler remedies work and you suspect there is a mechanical problem that cannot be solved by replacement of removable parts such as the nozzle or needle, contact the manufacturer or supplier or take your airbrush to a specialist service agent. Do not attempt to disassemble or repair delicate interior parts of the airbrush if you do not understand their function.

PROBLEM	POSSIBLE CAUSE	ACTION/REMEDY
Medium bubbles up in colour cup	Nozzle incorrectly inserted	Check seating of nozzle in airbrush body; tighten seal if necessary
	Damage to nozzle	Check and replace if necessary
	Damage to needle	Check and replace if necessary
No colour comes through nozzle	Blockage in nozzle	Clean nozzle; check needle and clear any paint residue; reassemble and flush out airbrush
	Medium too heavy	Empty colour cup; flush out airbrush; re-mix medium to more dilute consistency
	Supply of medium in colour cup has run out	Refill colour cup
	Blockage in paint channel or colour cup	Empty colour cup and flush out; clean outlet channel in colour cup
	Needle incorrectly aligned	Re-set needle
	Damage to nozzle	Check and replace if necessary
	Damage to needle	Check and replace if necessary
Loss of air through nozzle	Fault in compressor	Check functioning of compressor, pressure gauge setting and air hose connectors; refer compressor faults to service agent
	Passage of air through hose blocked	Check if hose is twisted or trapped

INDEX

ACKNOWLEDGEMENTS

The author would like to thank the following for practical
assistance: Jon Lloyd and Sheila Readwin at Daler-Rowney;
Brian Hayes and Martin Burt at The Airbrush and Spray
Centre, Worthing; George Weil and Sons Ltd, London.
Special thanks to Daler-Rowney and to Sally Stockwell.